D0250371

THE GIFT OF ART

THE PLACE OF THE ARTS IN SCRIPTURE

Gene Edward Veith, Jr.

INTER-VARSITY PRESS
DOWNERS GROVE
ILLINOIS 60515

InterVarsity Press is the book-publishing division of Inter-Varsity Christian Fellowship, a student movement active on campus at hundreds of universities, colleges and schools of nursing. For information about local and regional activities, write IVCF, 233 Langdon St., Madison, WI 53703.

Distributed in Canada through InterVarsity Press, 860 Denison St., Unit 3, Markham, Ontario L3R 4H1, Canada.

Portions of George Herbert's poem "The Agonie" on page 94 are taken from The Meditative Poem by Louis L. Martz. Copyright © 1963 by Louis Martz. Reprinted by permission of Doubleday & Company, Inc.

On page 95 are lines from "Gerontion" in Collected Poems 1909-1962 by T. S. Eliot, copyright 1936 by Harcourt Brace Javanovich, Inc.; copyright © 1963, 1964 by T. S. Eliot. Reprinted by permission of the publisher.

All quotations from Scripture, unless otherwise noted, are taken from the Revised Standard Version of the Bible, copyrighted 1946, 1952, © 1971, 1973.

A condensation of chapter two appeared in Christianity Today, 18 February 1983, p. 46.

ISBN 0-87784-813-0

Printed in the United States of America

Library of Congress Cataloging in Publication Data
Veith, Gene Edward, 1951-
 The gift of art.

 Bibliography: p.
 1. Arts in the Bible. I. Title.
BS680.A77V44 1983 220.8'7 83-18636
ISBN 0-87784-813-0

17	16	15	14	13	12	11	10	9	8	7	6	5	4	3	2	1
97	96	95	94	93	92	91	90	89	88	87	86	85	84	83		

To my parents,
Gene and Joyce Veith

1/ ICONS, ICONOCLASTS AND PHILISTINES 11

2/ THE GIFTS OF BEZALEL: THE BIBLE
AND THE VOCATION OF THE ARTIST 17

3/ THE IDOLATRY OF AARON:
THE MISUSE OF ART 29

4/ THE WORKS OF BEZALEL:
ART IN THE BIBLE 43

5/ THE HEIRS OF BEZALEL:
THE TRADITION OF BIBLICAL ART 63

6/ THE BRAZEN SERPENT:
ART AND EVANGELISM 79

7/ MERE ART 107

NOTES 127

Preface

This book is an exploration of what the Bible says and what it implies about art. It touches on theology, aesthetics, history and criticism, but it does not pretend to offer a comprehensive or definitive treatment of any of them. It is primarily an inspirational book, designed to offer guidance, suggestions and, I hope, some stimulation for Christians involved in the arts.

The word *art* I intend in its widest possible sense—painting, sculpture, crafts, music, poetry, fiction and all other aesthetic forms. I am not an expert in all these fields, nor am I an artist of any kind. I write as a critic, trained mainly in English literature.

I did not start my investigation with a thesis, trying to justify a certain theory from biblical texts or to support my own prejudices. Rather, my method was to study the Bible inductively and let my theories be shaped accordingly. To a certain extent I think I was successful, since some of what I found in Scripture and express

here runs squarely against my own taste and practice.

It will seem that what I take away with one hand I restore with the other. Some of this book will appear to minimize art, while elsewhere it will seem to exalt art out of all measure. This reflects the pattern of Scripture, which destroys with the all-consuming power of the law and then restores with the life-giving, liberating message of the gospel.[1] We need to understand the dangers of art if we want to fully know the extent of the freedom given artists by Scripture.

Thanks go to many friends and students who have made me aware of the problems of artists and the depths of their achievements. I should especially acknowledge Bob Scott, who first made me think about some of the issues in this book. Thanks also go to James W. Sire for encouraging me in this project. William Dyrness and Nicholas Wolterstorff, who read the manuscript, made many helpful comments. I am also grateful to Jane Wells for her cooperation and for her prompt, generous and professional editing. Thanks especially to Jackquelyn Veith for her help and support.

1
Icons, Iconoclasts & Philistines

THE ARTS HAVE ALWAYS BEEN A CONCERN OF THE CHURCH. ON THE ONE hand, Christianity has nourished the arts like no other philosophical or religious system. On the other hand, Christians have also mistrusted the arts, seeing in them the dangers of idolatry and worldliness. In addition, of course, there have been the many Christians who accept art uncritically, who use art for its decorative or emotional associations, for example, rather than its aesthetic qualities or theological meaning. There is a tradition of bad religious art—medieval garish crucifixes with lots of blood, nineteenth-century doe-eyed Madonnas, modern religious knickknacks—just as there is a continuing tradition of greatness. It follows that serious Christian artists, then, are sometimes venerated, sometimes attacked and often ignored.

As a study of what the Bible says about art, this book sheds light on each of these positions, showing that each has a certain basis

in biblical truth but also leans toward a certain error. The icon worshipers, the iconoclasts and even the "Philistines" who are completely indifferent to artistic and cultural values have something to teach Christians involved in the arts. But none of them fully presents a biblical view of art.

Radically Differing Views

Christians have historically taken two extreme positions in regard to the arts. Some have valued art in an extreme and radical way, constructing and venerating icons, works of art that are seen as religious objects which inspire and focus the devotions and prayers of the faithful. Other Christians, the iconoclasts, have made a point of rejecting art, at least in its religious dimension, insisting that the worship of the invisible God permits no "idolatrous" use of art. These two factions have been in conflict within the church from the very beginning. In the early church, the East was dominated by iconoclasts and the West by devotees of the icon. Later, ironically, it was the Eastern church that developed the most elaborate theology of icons. The Reformation was generally accompanied by iconoclasm. Art, then, has always been an issue in the church.

That both icon makers and icon breakers have been part of the history of the church suggests that both have a certain grounding in biblical truth but that both are also making a particular error. As this book will demonstrate, the Bible has a great deal to say about art. In general, the arts—sculpture, painting, music, literature—are sanctioned by God. Those who honor icons are correct in valuing works of art and in using art to express God's Word. The Bible does warn, however, against worshiping art, using it to promote falsehood or confusing aesthetic experience with religious truth. The iconoclasts have something to teach us.

Today the arts are sometimes used as substitutes for religious faith. A friend of mine says, "My religion is art." His desire for

transcendence, values and meaning are all satisfied by aesthetic experience, by attending a symphony or reading great poetry. Secular aestheticism is a great rival to Christianity, especially in academic and artistic circles, among advocates of "high culture." Here the voice of the iconoclasts is necessary to insist that human beings cannot save themselves by worshiping their own creations, however magnificent, that we cannot make our gods but that the true God made us and sent his son to redeem us. In proclaiming the gospel we need to cast down idols of all kinds, even if they are aesthetically beautiful.

This does not mean that Christians must reject art out of hand, though, or that we are not to enjoy symphonies or poetry. This too would go against the clear statements of Scripture. Human beings can make anything into an idol, can misuse any of God's gifts. But fear of misuse is no reason to reject the gift.

The Purpose of This Book

This book is a study of what the Bible teaches about art. It is directed against both secular aestheticism, the attempt to make art into a religion, and the antiscriptural tendency to reject the arts altogether. It tries to show how, in giving art its true place, Scripture liberates both art and the artist. If art does not have to be a religion, it is freed to pursue its own nature.

I also attempt, throughout, to address some of the problems faced by Christians in the arts. By and large, the contemporary artistic and literary establishments are opposed to Christianity. Existentialism, Zen, psychotherapy and pop-religions are respectable enough, with moral hedonism and Bohemian trendiness reigning supreme; but Christianity is generally looked down on. This is to be expected, of course; that Christianity will not be popular in the eyes of "the world" is fully explained in Scripture. Although all Christians, according to Scripture, should be facing this

problem, the Christian artist is probably more aware than others of the hostility of the world.

A more painful difficulty is that Christians in the arts are not always supported by other Christians. The problem today is not so much with the classic struggle between icon worshipers and iconoclasts, both of whom took art seriously, but with what might be described as "Christian Philistinism" (notice the discord between the two terms). I was recently a visiting faculty member at a Christian college which was exhibiting on its grounds some abstract sculptures by a Christian artist. Their presence brought out the Jeremiahs in the student body, who denounced the idols of secular humanism and the wickedness of modern art. Eventually somebody stole one sculpture and hauled it to the football field. Another college I was associated with erected a realistic statue of Moses, which occasioned no such protests. If the real Jeremiah were here, he would probably object more to the realistic statue than to the abstract one. The Second Commandment, understood narrowly, would reject representational art, but the ancient Hebrews understood it to permit nonrepresentational designs, that is, abstract art.

The point is, Christians who desire to be conservative and biblical are often limited and narrow in their aesthetic tastes, not examining what theology and the Bible really say about art. Many Christians, and here they are in agreement with the public at large, believe that poetry must always rhyme, convey pleasant thoughts and be sentimental. A good novel would be similar to a Harlequin romance: just eliminate the sex and set the story in Bible times. Paintings must be of something immediately recognizable; biblical scenes are best, but sunsets, flowers and nature scenes are also permissible. Above all, art must be representational; abstract art is usually rejected in principle even by sophisticated Christians.

I do not wish to ridicule Christians who are against art or who have conservative tastes. There is danger in art. Contemporary

art forms do originate in non-Christian world views, as Francis Schaeffer and others have shown. The fragmentation, pessimism and abstractionism of modern art have developed at least partially out of the idea that, since the external world is harsh and meaningless, human beings must create their own meanings from within themselves. Moreover, modern art has become elitist, scorning "ordinary" people with their simple taste, thus cutting itself off from its audience and from ordinary human experience.

Christian artists cannot, however, escape their contemporary context. They do not accept much of the philosophy that dominates modern art, but as denizens of the twentieth century they cannot help but be contemporary. Their training and their imaginations are conditioned by the whole history of art, which they cannot and dare not avoid. It is not possible to write seventeenth-century poetry today or to paint eighteenth-century paintings. If Christian artists must express their faith only in old-fashioned modes, it implies to their audiences and peers that Christianity is an outmoded religion, with nothing to say to the needs and imagination of the modern condition.

Christian artists, then, are faced with many dilemmas. The artistic establishment rejects their Christianity, while fellow Christians tend to reject their art. Moreover, they are haunted by other questions: Can one be both contemporary and Christian, or should Christianity in the arts recapture older forms? Is it possible to be both biblical and original? Is art a legitimate vocation for a Christian who desires to serve God? Does any of this matter in a world that is lost without the gospel?

Faced with enormously difficult issues such as these, Christians should ask, What does the Bible say? It is possible to debate such problems endlessly, but Christians have recourse to an ultimate authority. Although the Bible's main subject is the history and the plan of salvation, it encompasses all of life, including art. The Bible

has much to say about art, about both its misuse and its value as a gift of God. Since the Bible itself makes use of aesthetic principles, it can serve as an example as well as a guide for Christian artists. The Word of God gives warning but also encouragement to Christians involved in the arts. It gives a context for art, showing how God relates to the artistic process and how others have served God through the making of aesthetic forms.

Chapter two presents the positive teachings of Scripture on the vocation of the artist. It finds a model in Bezalel, whom God called to construct the tabernacle and whom he empowered with specific gifts, all of which are needed by every artist. It also describes the biblical purpose of art: the elaborate designs God commanded for his service were to be "for glory and for beauty." Chapter three shows how God's gifts and purposes for art can be twisted into idolatry. Aaron, the maker of the golden calf, is the example, and the discussion extends into "secular aestheticism," the attempt to make art into a religion. Chapter four, on the specific works of art described in the Bible, ranges from the abstract designs in the tapestry of the tabernacle to the symbolic representations of the ark of the covenant.

In chapter five I explore what may be called the Hebraic imagination, showing its difference from the classical Greek imagination, which has become normative in our culture. A brief historical survey shows how Christians in many different ways have, in fact, been following the biblical principles for art. Then follows a chapter on a perennial issue for Christians in the arts: In what sense can art participate in the work of evangelism? What are the possibilities and the limitations of specifically religious art in communicating Jesus Christ? The final chapter offers some relevant thoughts, for the artist and for those who would appreciate it properly, about the limits and the glory of art.

2
The Gifts of Bezalel: The Bible and the Vocation of the Artist

WHEN THE CHILDREN OF ISRAEL HAD BEEN REDEEMED FROM THE SLAV-ery of Egypt, the Lord established a covenant that placed nearly every aspect of ordinary human life under the will of God. Having been given the moral law through the Ten Commandments, the social law for the theocratic community and the ceremonial law detailing the worship that the Lord would find acceptable, Moses on Mount Sinai was told of the calling and empowering of artists (Ex 31:1-11). Later Moses repeated what God had said:

> And Moses said to the people of Israel, "See, the LORD has called by name Bezalel the son of Uri, son of Hur, of the tribe of Judah; and he has filled him with the Spirit of God, with ability, with intelligence, with knowledge, and with all craftsmanship, to devise artistic designs, to work in gold and silver and bronze, in cutting stones for setting, and in carving wood, for work in every skilled craft. And he has inspired him to teach, both him and Oholiab the son of Ahisamach

of the tribe of Dan. He has filled them with ability to do every sort of work done by a craftsman or by a designer or by an embroiderer in blue and purple and scarlet stuff and fine twined linen, or by a weaver —by any sort of workman or skilled designer. Bezalel and Oholiab and every able man in whom the LORD has put ability and intelligence to know how to do any work in the construction of the sanctuary shall work in accordance with all that the LORD has commanded."

And Moses called Bezalel and Oholiab and every able man in whose mind the LORD had put ability, every one whose heart stirred him up to come to do the work. (Ex 35:30–36:2)

Three Biblical Principles

In this passage several principles about art emerge. First, *art is within God's will*. The tabernacle, designed to glorify God and to instruct his people, was to involve "artistic designs." The worship of the true God was not to be out in the woods or on the "high places," as in the pagan nature religions (Deut 12:2-5), nor was it to be in a bare, unfurnished tent. Rather, "you shall make the tabernacle with ten curtains of fine twined linen and blue and purple and scarlet stuff; with cherubim skilfully worked shall you make them" (Ex 26:1). The furnishings were to be of pure gold, delicately carved wood and precious stones (Ex 25).

The Lord's requirements for the tabernacle and later the Temple do, in fact, take up a good part of the Old Testament, as many well-intentioned people who resolved to read through the entire Bible have found out to their dismay. The details of how many hooks to place in the curtains, how many cubits the frames must be, what to cover with beaten gold and what to make from bronze, are tedious to modern readers and have led to the abandoning of many a Scripture-reading project. But it pleased God to include them in his holy Word. God, the designer and maker of the universe, clearly places great value on details of design, construction and artifice.

Why was everything to be so lavish? The Lord tells Moses that "you shall make holy garments for Aaron your brother, for glory and for beauty" (Ex 28:2). The gold filigree, the twisted chains of gold, the emeralds, sapphires and diamonds, the golden pomegranates and bells, the woven coat, the girdle "embroidered with needlework" (28:39) were to be made "for glory and for beauty." God was to be glorified. Only the finest, the best that human beings have to offer, whether possession or talent, is appropriate to glorify the Lord. Also, the glory of the tabernacle seems to have been understood as a reminder, a faint copy of heavenly glory (Ex 24: 9-18; 25:40; Heb 8:5). Those dazzled by the sublimity of the tabernacle were perhaps experiencing a glimpse of the much more dazzling grandeur of the infinite God enthroned on "as it were a pavement of sapphire stone, like the very heaven for clearness" (Ex 24:10). Besides manifesting glory, Aaron's garments were to be "for beauty." Beauty is an appropriate end in itself—the garments were to be made *for* beauty. The inventor of colors, of form, of textures, the author of all natural beauties, values the aesthetic dimension *for its own sake*. According to the clear statements of Scripture, art has its place in the will of God.

The Scripture also points out that *artistic ability is God's gift*. "And Moses called Bezalel and Oholiab and every able man in whose mind the LORD had put ability, every one whose heart stirred him up to come to do the work" (Ex 36:2). All who wanted to help make the tabernacle, "whose heart stirred him up to do the work," did so because the Lord had put ability in their minds. Artistic talent is not to be thought of as some innate human ability, nor as the accomplishment of an individual genius, but as a function of grace. God "fills with ability," puts ability in the minds.

Calvin, commenting on this passage, argues that every great human accomplishment in the arts or the sciences, even among nonbelievers, is a gift of the Holy Spirit. "The knowledge of all

that is most excellent in human life is said to be communicated to us through the Spirit of God" (*Institutes* 2.2.16).[1] This is not to say that the gifted pagans had the Holy Spirit in the same way believers do. Rather, the Spirit distributes the gifts of "common grace," which are through God's incredible generosity poured out on believers and nonbelievers alike:

> If we regard the Spirit of God as the sole fountain of truth, we shall neither reject the truth itself, nor despise it wherever it shall appear, unless we wish to dishonor the Spirit of God. For by holding the gifts of the Spirit in slight esteem, we contemn and reproach the Spirit himself. What then? Shall we deny that the truth shone upon the ancient jurists who established civic order and discipline with such great equity? Shall we say that the philosophers were blind in their fine observation and artful description of nature? Shall we say that those men were devoid of understanding who conceived the art of disputation and taught us to speak reasonably? Shall we say that they are insane who developed medicine, devoting their labor to our benefit? What shall we say of all the mathematical sciences? Shall we consider them the ravings of madmen? No, we cannot read the writings of the ancients on these subjects without great admiration. We marvel at them because we are compelled to recognize how preeminent they are. But shall we count anything praiseworthy or noble without recognizing at the same time that it comes from God? (*Institutes* 2.2.15)

The Holy Spirit that was involved in creation, "moving over the face of the waters" (Gen 1:2), continues to be at work in and through the creation. "He fills, moves, and quickens all things by the power of the same Spirit, and does so according to the character that he bestowed upon each kind by the law of creation" (*Institutes* 2.2.16). The arts and the sciences are built into creation, into the divinely fruitful fabric of existence and into the human being as the image of

God. They are nonetheless gifts from a gracious God.

The Exodus passage not only states that artistic talent is from God, but it goes on to detail the specific gifts needed by an artist. The entire passage is so incisive in its analysis of what artistry involves—indeed, it is the most comprehensive analysis of the issue that I have ever found—and it is so important to the vocation of the Christian artist that it deserves our close attention.

These gifts should not be thought of as some zap from Mt. Sinai which changed a bumbler with ten thumbs into an artistic genius. Bezalel no doubt was a skilled craftsman, in the normal course of things, before he received this divine commission. He was perhaps the sort of slave who executed the great art of the ancient Egyptians. The Lord speaking to Moses indicated that he has already given these gifts to Bezalel ("I *have* called . . . I *have* filled . . . I *have* given to all able men ability" [Ex 31:2-6]). Moses now must go tell Bezalel what he is to do; the specific "call" or commission to make the tabernacle came to him from a human being (Ex 36:2), but his abilities were given him by God. As matters of "common grace," these gifts apply not only to Bezalel but to all artists.

"See, the LORD has called by name Bezalel the son of Uri, son of Hur, of the tribe of Judah" (Ex 35:30). *Art is a vocation from God.* The word *vocation* means "calling." We think of callings in terms of the ministry or mission work, but the Reformation stressed that even the most secular occupations are true, God-given vocations, suitable for the service of God and other people. The Scripture here states clearly that God "called" Bezalel for the work of constructing and adorning the tabernacle. This calling was not generalized, addressed to everyone; it was personal, a special calling—the Lord called him by name. A person may be called by God to be an artist.

Gifts for the Artist
"He has filled him with the Spirit of God" (Ex 35:31). This is the first

gift given to Bezalel, and the most important for the Christian artist. Bezalel is the first person described in the Scriptures as being filled with the Holy Spirit. According to the New Testament, the Holy Spirit is given to all Christians and bears fruit in many areas of life (Gal 5:22-23; Eph 5:9). Here it is associated with the empowering of Bezalel "to devise artistic designs." Artists often speak of being inspired, of writing or creating more than they know, of surrendering to a creative power that is within them and yet transcends them. To say an artist is "inspired," of course, does not mean the same as saying the Bible is inspired, and there is danger, as the next chapter will show, in overmysticizing the artistic process. Nevertheless, the Scripture does indicate that the Spirit of God inspired Bezalel in the making of the sanctuary. Granting Calvin's point that the Holy Spirit distributes the gifts of common grace, it seems that Bezalel's possession of the Holy Spirit means something even more fundamental. Having the Spirit means that Bezalel was a person of faith. To be filled with the Holy Spirit is to be intimate with the Lord, knowing him personally and deeply, surrendering to his will and his presence. This gift is a matter of "special grace" rather than common grace. A Christian artist must, above all, be a Christian. The first priority must be his or her relationship to God through Christ, a work of the Holy Spirit in the heart. If the artist is first "filled with the Spirit of God," as Bezalel was, the other gifts can follow.

"He has filled him... with ability" (35:31). The second gift given to Bezalel was talent. Not everyone is able to paint or to carve; not everyone can write great poetry or act or sing or play the violin. The potential to do so, the aptitude, the "ability," even if it is not always used, is God-given.

"He has filled him... with intelligence" (35:31). The third gift is intelligence. A person may have talent, but that alone is not enough for great or God-pleasing art. God gave Bezalel a measure

of understanding, of reason, of common sense. The modern image of the artist as irrational, passionate, completely intuitive, is countered here by the idea that the artist, however inspired and talented, must also be intelligent. He must manifest the clear mind and rational temperament necessary for solving the practical problems of making art. Designing a sculpture that will not tip over, managing the laws of perspective and geometry in painting, or deciding how to choreograph a play all involve an almost mathematical way of thinking. Intelligence also implies a way of looking at life. Great art is always incisive, the work of a mind that sees through partial perceptions and stereotypes. The popular image of the creative person notwithstanding, the great artists that come to mind—da Vinci, Cervantes, Shakespeare, Coleridge, Bach—all display this keen, analytic frame of mind. When we were studying *The Divine Comedy*, one of my students, an agnostic, wrote how impressed he was by Dante's "intelligence." Such a tribute is appropriate for one of the greatest and most passionate of all our poets.

"He has filled him... with knowledge" (35:31). The fourth gift is knowledge. Whereas intelligence involves the faculties of the mind, knowledge involves the content of the mind. Bezalel, in addition to talent and mental acuity, needed to *know* certain things. He needed to recognize and know how to prepare acacia wood. He needed to know how to cast bronze and how gold can be beaten to microscopic thinness without tearing. Besides knowing his materials, he had to know his subjects: both the natural—the structure of almonds, flowers and pomegranates—and the supernatural—the appearance of the cherubim and the meaning and function of the mercy seat.

Some artists scorn education. Their gifts are "natural," they think, a function of their inner creativity that they need only express without inhibition, without tradition, without knowledge of anything outside themselves. The Scriptures, however, say that

knowledge of things beyond the self is important for an artist.

All artists who are good do, in fact, tend to be open to knowledge. They are interested in learning about their art, its history and traditions. They are interested not only in their own work but in that of others, especially the great masters of their craft. In my experience, real artists also want to know things besides art—physics, geography, anthropology, history, politics. They read books. They tend to agree with Samuel Johnson that they would rather know something, no matter how trivial, than to remain ignorant about it. They seek knowledge not only to find subjects for their art, although wide reading certainly increases the scope and depth of one's work, but also because an openness to the outside world seems to be a hallmark of true sensitivity, the prerequisite of an artist.

For a Christian artist the most important knowledge is of the Holy Scriptures. And the Bible teaches us two important points that Christian seekers of knowledge need to realize. First, "knowledge puffs up" (1 Cor 8:1). There is no merit to knowledge, no moral or spiritual superiority to the intellectual life; in fact, the danger of pride is particularly insidious to the person of knowledge, as is the temptation to build our lives on our own understanding rather than the external revelation of Scripture. True knowledge of God's Word, though, is a certain cure for human pride and self-sufficiency.

Second, Scripture warns us to be "wise unto that which is good, and simple concerning evil" (Rom 16:19 KJV). We are to feast upon the true, the honorable, the pure, the lovely, the gracious, the excellent, the praiseworthy (Phil 4:8). On the other hand, "fornication and all impurity or covetousness must not even be named among you, as is fitting among saints" (Eph 5:3). Some classes of experience Christians must shun completely. We are to be "simple" in regard to evil; that is, we are to be ignorant, innocent, naive—

notice the extremely negative connotations of those words in our culture—in regard to activities that Scripture forbids.

This is neither easy nor pleasant, but it is binding. Artists in particular are tempted to follow every experience no matter where it leads. The Bohemian assumption is that, to be a true artist, one must experience all of life. Many artists experiment with drugs, for example, to heighten their consciousness, or even expose themselves to physical danger or moral degradation so that they can truly "know" life in all its fullness, so that their art will have scope, depth, and reflect "real" life. But the Bohemian assumption that art depends on the artist's experience does not seem valid to me. Stephen Crane advocated this principle in his writings and practiced it in his short life. His greatest work, however, was *The Red Badge of Courage*, a vivid evocation of combat during the Civil War. Veterans of the war praised its accuracy, its re-creation of what war felt like. Actually, the twenty-four-year-old author, although he was later a war correspondent, had never seen a battle.

Great art is a function of imagination more than experience. We can know the depths of sin by honestly examining ourselves through the lens of Scripture, without committing more sins, which in fact "harden the heart," sear the conscience and make us less—rather than more—sensitive and open to the truth (see Rom 1:18-32). *Real* knowledge, in contrast, is God's gift for art.

"He has filled him with . . . all craftsmanship" (35:31). In addition to talent, intelligence and knowledge, an artist needs craftsmanship, the mastery of technique. Craftsmanship involves skill at working with one's medium, whether words or paint or stone, causing that medium to do one's bidding, to embody an idea, to assume an aesthetic form. In artistic craftsmanship, the human dominion over nature is perhaps at its highest (Ps 8:6). Not a tyranny or an exploitation, the dominion of the artist over matter involves intimacy and commitment as the object, through infinite

care and effort, begins to conform to the artist's will. Scripture goes further. It sees in artistic craftsmanship, the recurring figure of the potter and the clay, an analogy of the relationship between God and his people (Is 64:8; Jer 18:6; Rom 9:21).

The preceding gifts—ability, intelligence, knowledge and craftsmanship—were all necessary for Bezalel "to devise artistic designs" (Ex 35:32). Whereas human theories about art sometimes emphasize talent, sometimes training and sometimes technique, Scripture states that all are necessary for the artist. It is characteristic of human theories, however excellent, to be partial and narrow. As G. K. Chesterton shows in *Orthodoxy*, it is characteristic of Scripture (and of truth in general) to be comprehensive. Having delineated so completely the prerequisites for artistry, the Lord adds another gift.

The Teaching Artist
"And he has inspired him to teach" (Ex 35:34). Most artists find themselves teaching. Many are disappointed that they cannot support themselves solely by their work, that they must teach to make a living. Actually, Scripture implies that teaching is as much related to art as craftsmanship or any of the other gifts are. Whether one teaches in a college, a public school, an arts and crafts shop, or in the time-honored relationship of master and apprentice, teaching is by God's design part of the artistic vocation.

The centrality of teaching implies something further about the artistic gifts. Not only was Bezalel given the gifts necessary to build and adorn the tabernacle, but he was further empowered (the Bible uses a wonderful term, "inspired") to transmit these gifts to others. Since art depends on such intangible and inherent qualities as talent and craftsmanship, the question is often raised whether artistry can really be taught at all. Scripture, while agreeing that art involves supernatural gifts, says clearly that it can be taught.

The Holy Spirit does not usually operate without means; that is, the gift of grace comes to us through the Word of God, whether from reading the Scripture, hearing a sermon, experiencing the sacraments or hearing the gospel through shared witness (Rom 10:14-17). God normally communicates his gifts through human instruments. The same is true for art. An aspiring artist may have many innate talents, but those talents normally come to fruition only through the efforts of a teacher. Conversely, an artist who is a teacher can pass his or her gifts to students. This does not mean that the student's abilities are any less dependent on God's gifts, or that a good teacher can automatically teach anyone to be an artist. It simply means that teaching and learning are the normal means by which God offers his gifts—ability, intelligence, knowledge, craftsmanship, teaching—to those he has chosen for the artistic vocation, to "every one whose heart stirred him up to come to do the work" (Ex 36:2).

For Glory and for Beauty

We must not draw too much from the example of Bezalel, however. He lived under a different covenant. The tabernacle with its animal sacrifices has been fulfilled by the Incarnation—God "tabernacling" with us (Jn 1:14)—and the atonement of Jesus Christ. We should not try to justify elaborate church buildings just because the tabernacle was so elaborate. Worship is different now. Bezalel was called for a specific purpose; artists sometimes have other purposes that may be more problematic. Nor was Bezalel, the desert craftsman, in the "high art" tradition. He was not creating for art museums, nor did he have the same consciousness about art or the artist as we have in our culture. Scripture has other things to say about art, including the possibility that artistic works can lead others to a false religion. (The dangers of art will be discussed in chapter three.)

Nevertheless, there can be no doubt that "artistic design" and the purposes of "glory and beauty" are sanctioned by the Word of God. Anyone who rejects the aesthetic dimension of life or who denies that art is an appropriate vocation for a Christian does so against the clear statements of Scripture. The account of the calling of Bezalel gives an authoritative model of the artistic vocation, describing in surprisingly comprehensive detail the gifts God offers to artists.

3
The Idolatry of Aaron:
The Misuse of Art

EXODUS 31 SETS FORTH THE BIBLICAL FOUNDATION FOR THE VOCATION of the artist. The very next chapter, Exodus 32, describes God's purposes for art gone completely awry, with a gifted artist creating an object that gives rise to sin and apostasy.

When the people saw that Moses delayed to come down from the mountain, the people gathered themselves together to Aaron, and said to him, "Up, make us gods, who shall go before us; as for this Moses, the man who brought us up out of the land of Egypt, we do not know what has become of him." And Aaron said to them, "Take off the rings of gold which are in the ears of your wives, your sons, and your daughters, and bring them to me." So all the people took off the rings of gold which were in their ears, and brought them to Aaron. And he received the gold at their hand, and fashioned it with a graving tool, and made a molten calf; and they said, "These are your gods, O Israel, who brought you up out of the land of Egypt!"

When Aaron saw this, he built an altar before it; and Aaron made proclamation and said, "Tomorrow shall be a feast to the LORD." And they rose up early on the morrow, and offered burnt offerings and brought peace offerings; and the people sat down to eat and drink, and rose up to play. . . .

When Joshua heard the noise of the people as they shouted, he said to Moses, "There is a noise of war in the camp." But he said, "It is not the sound of shouting for victory, or the sound of the cry of defeat, but the sound of singing that I hear." And as soon as he came near the camp and saw the calf and the dancing, Moses' anger burned hot, and he threw the tables out of his hands and broke them at the foot of the mountain. And he took the calf which they had made, and burnt it with fire, and ground it to powder, and scattered it upon the water, and made the people of Israel drink it.

And Moses said to Aaron, "What did this people do to you that you have brought a great sin upon them?" And Aaron said, "Let not the anger of my lord burn hot; you know the people, that they are set on evil. For they said to me, 'Make us gods, who shall go before us; as for this Moses, the man who brought us up out of the land of Egypt, we do not know what has become of him.' And I said to them, 'Let any who have gold take it off'; so they gave it to me, and I threw it into the fire, and there came out this calf." (Ex 32:1-6, 17-24)

The people who would so generously bring their possessions as offerings for the adornment of the tabernacle (Ex 35:4-9; 36:3-7) here bring them for the casting of an idol. Aaron, the eloquent high priest, uses his gifts and his office to proclaim the worship of a god he has made. The picture is of offerings, ceremonies and art all misdirected.

Art Gone Awry

At the focus of the apostasy is an object of art, a golden calf. A piece of sculpture is honored as the god "who brought you up out of the

land of Egypt." Not only is visual art misused, but Aaron's gift of language is used to make proclamations about the god of his own making. Even music, a nonrepresentational art form, is used sinfully as singing and dancing are offered to a false god. Just as art can be used in the name of the true God, as shown in the gifts of Bezalel, so it can be used in an idolatrous way, supplanting the place of God and thereby distorting its own nature.

The essence of idolatry is explained in Romans 1:25: "They exchanged the truth about God for a lie and worshiped and served the creature rather than the Creator." Human depravity is such that we have the tendency to direct our faith not to the true God who made the universe but to various "creatures." We tend to honor what is made rather than the One who made it, the very source of all we find so attractive in the "creatures."

God's creations are certainly good (Gen 1:31), but this does not mean that they are to be worshiped or served. No mere creature is to be seen as ultimate or allowed to usurp the Creator's place in our lives. Those who explicitly worship nature, whether primitive animists or more sophisticated pantheists, are guilty of idolatry, as are materialists who ascribe attributes of deity such as infinity and eternity to the physical universe. Another perhaps more insidious type of idolatry is the worship of creatures made by human beings (see Psalm 115). Any manmade religious system apart from God's self-revelation given in his Word is idolatrous, even though it may be highly conceptualized and abstract. Our self-made personal religions in which we put together various assumptions that we "like" rather than what is true can easily be idolatrous. So can trusting in our own "works" for salvation rather than the work of Christ.

Yet idolatry is more than simply having a false religion. This passion for things rather than the Person who made them manifests itself on nearly every level of our lives. Thus Colossians 3:5 states

that covetousness, the unlawful desire for material possessions, is idolatry. A person, rich or poor, who devotes his or her life to accumulating more and more wealth is in danger, it would seem, not so much of dishonesty—morally one could be above reproach—but of idolatry, of being so oriented to "this world" that in affections, time and service the Lord is displaced by his "creatures" (compare Lk 16:13; 18:24-27).

Anything, even if it is good in itself, can be the occasion for idolatry. Whether it is a once-useful and soul-winning religious artifact like the bronze serpent (2 Kings 18:4) or even a member of one's own family (Mt 10:37), it can take the Creator's place in our lives. No wonder Scripture spends so much time warning us against idolatry! It is not merely the practice of primitive nature religions that no one believes in anymore anyway, but it is rather a sin that inheres in the very core of our being, an inclination that is always present in us, from which we are saved only by the blood of Christ.

No Graven Image

The Second Commandment reads as follows:

You shall not make for yourself a graven image, or any likeness of anything that is in heaven above, or that is in the earth beneath, or that is in the water under the earth; you shall not bow down to them or serve them; for I the LORD your God am a jealous God, visiting the iniquity of the fathers upon the children to the third and the fourth generation of those who hate me, but showing steadfast love to thousands of those who love me and keep my commandments. (Ex 20:4-6)

The essence of the commandment is the jealousy of God, a startling but beautiful expression of God's love for us. It is not mere, abstract good will but, like all love even on the human level, is a passionate longing for another person; it involves the greatest pain and anger when the beloved rejects the lover for someone or something else.

When one of his beloved commits idolatry, God feels it like a loving husband whose wife commits adultery, a figure consistently and powerfully employed in Scripture (Jer 3; Hos 1—3). This jealousy is the other side of the coin of God's steadfast love.

The commandment specifically forbids making a "graven image, or any likeness of anything," whether in the heavens, the earth or the water. Some have taken these words to forbid art altogether. I believe this view misreads the commandment. Bowing down and serving the images constitute the idolatry, not manufacturing them. The "likenesses" that are forbidden no doubt refer, on one level at least, to the specific pagan religions that were always competing for the Israelites' faith: the worship of the stars, planets and "sky gods" (Deut 4:19); the worship of animals, chthonic deities and "earth goddesses" (the golden calf, Baal, Ashtaroth); the worship of water deities such as the fish-gods, the leviathans and others common among the Egyptians and Canaanites.

To assume that the Second Commandment forbids any representational art would seem to contradict the orders given for the construction of the tabernacle and the Temple, which called for cast figures of flowers and even oxen (2 Chron 4:3-5). Nevertheless, if taken in its most narrow sense, as it has often been by some Jews and Christians throughout history, the prohibition against likenesses still does not rule out all art. It makes room for the vast range of nonrepresentational art, including the much maligned abstract art, the symbolic and the fictional, as will be discussed in later chapters. Yet one must be careful not to deny the full force of the commandment as it applies to art. Not only may we not worship idols; we may not *make* any object for worship. The Second Commandment clearly states that we must not worship art or create art to be worshiped.

Secular Aestheticism
What is it to worship art? Rather than taking the anthropological

approach and criticizing the ancient Canaanites, consider some commonplaces that are heard over and over again in academic and artistic circles: "Art is the means of giving order to the chaos of experience." "Art represents the source of human values." "Art gives meaning to life." These statements, of course, reflect the modern existentialist assumption that meaning is something bestowed or imposed by the individual on a meaningless world. They place art and the artist squarely in the position of God—as creator, lawgiver and redeemer.

Matthew Arnold predicted that, as human beings continue to progress, religion would be replaced by poetry. Although his thesis has been generally rejected not only by the religious but by poets who dislike being put into such a position, it has in fact, to a degree, been happening. This mystification of art is evident on several levels. For instance, religious terms—"inspiration," "vision," "creation," "transcendent," "myth," "revelation"—have now become part of the language of aesthetics. Often the artist is described as a special person, one set apart from society and common life, endowed with mystical powers and authority. In other words, the artist is held to be a mystical seer, a prophet or a shaman.

The work of art is treated as an oracular utterance of inexhaustible depth, an authoritative guide to life. Literature and art are often presented as esoteric mysteries—the masses are excluded by its obscurity. The few are initiated into its mysteries in college courses taught by its high priests, the professors and critics who transmit the sacred knowledge, construct theologies and preserve the blessed relics of the departed saints. Besides the professional clergy are the laity who, often motivated by guilt, give substantial offerings not to the church but to "the Arts." Dressed up in their best clothes, they make up the congregation of the concert hall or the theater and find the key to a richer, more meaningful life in pursuing aesthetic pleasure.

I do not mean to ridicule the modern intellectual and artistic establishment. (Indeed, I speak as one who has solemnly analyzed, studied and edited several of Walt Whitman's address books.) Yet for many people, especially in academia and artistic professions, religion has been displaced completely by the quasi-religious stature given to "high culture." Ironically, this secular aestheticism assumes as a religion the form of the most primitive, credulous and unsophisticated religions with its priestcraft (intellectual elitism and hermeticism), superstitious veneration of relics (devotion to the address books of great poets and the most trivial works by recognized artists), and lack of rigorous moral directives. The religion of modern secular aestheticism is, in fact, structurally similar to that of the ancient Canaanites. The Christian artist can avoid contact with it no more than the Hebrews could avoid "the peoples of the land." To both, the temptations are sometimes compelling.

This milieu, so familiar to Christians in academia and the arts, with its sophisticated intellectualism and moral permissiveness, with its overwhelming attractiveness and tendency to make one embarrassed to be a Christian, is also called worldliness. It is analyzed many places in Scripture, most notably Romans 1:

> *Although they knew God they did not honor him as God or give thanks to him, but they became futile in their thinking and their senseless minds were darkened. Claiming to be wise, they became fools, and exchanged the glory of the immortal God for images resembling mortal man or birds or animals or reptiles.*
>
> *Therefore God gave them up in the lusts of their hearts to impurity, to the dishonoring of their bodies among themselves, because they exchanged the truth about God for a lie and worshiped and served the creature rather than the Creator, who is blessed for ever! (Rom 1:21-25)*

Idolatry can be naive or sophisticated. It is subtle and enormously

compelling for fallen human beings. It is not restrained by time or place, and secular aestheticism is only one of its forms. At its root is the primal sin, humanity's inherent rebellion against the true Creator. Art, unfortunately, is often the means by which man worships himself.

The Christian artist is delivered from these falsehoods. Saved by the blood of Christ and no longer under the law, the Christian artist is given the widest liberty. Art does not have to bear the burden of "giving meaning to life." It can fulfill its own nature rather than the very different nature of religion. A biblical view of art that avoids idolatry will, it seems to me, distinguish between the aesthetic and the religious and will involve a certain kind of caring for its audience.

The Aesthetic and the Religious
Art does possess intrinsic values, which are often confused with spiritual values. The calf of solid gold must have been splendid to see. It must have been breathtaking as it caught the sun and later the firelight. It is little wonder that the people who experienced its beauty and mystery would confuse those feelings with the beauty and mystery of the Lord. Indeed, its beauty must have been more immediate and accessible than that claimed for the God who veiled himself in the pillar of fire and the pillar of smoke. Aesthetic experiences can indeed be very close and are perhaps related to religious experiences, yet they are not the same. I tend to agree with the Neo-Platonists that earthly beauty—the grandeur of nature, a sublime poem, a glorious symphony—is a participation in the divine beauty that is its source and can elevate the consciousness to a realization of God. Yet the aesthetic objects or, worse, the human beings who made them, are often taken as being themselves absolute, the source and end of the values that they embody. Certainly art can be awe-inspiring, mysterious, peaceful and prophetic,

but these strengths of great art can cause it to be confused with the sphere of religious truth.

This confusion is complicated by the fact that the effect of art, even in offering the highest values, is to give pleasure. Aesthetic experience by definition involves pleasure of various kinds. (Certainly art also deals with pain and even horror—it is not always "pleasant." A great tragedy, however devastating, nevertheless gives its audience a sense of satisfaction, a positive aesthetic enjoyment deriving from its form, which is distinct from the "pity and fear" created by its content.) Pleasure is part of the gift of art and should never be ascetically rejected on principle. The point is simply that art is generally pleasurable, while true religion frequently is not. The splendor of the golden calf was very different from the splendor that was breaking out on Mt. Sinai, terrifying the people (Ex 20: 18).

The living God does not exist to gratify people. Art, of course, does. Moreover, art can gratify them through quasi-religious experiences which are under human control. God, on the other hand, is never under human control. Idolatry, whether it be a homemade religion of positive thinking or a comfortable aestheticism, can offer a sort of domesticated spirituality. Our yearnings for transcendence, for meaning, for value, can be met to a degree in, for example, an overwhelming symphony, without the pain of repentance and the cost of discipleship, without what Flannery O'Connor has called "the sweat and stink of the cross."[1] Properly, the sense of transcendence in a symphony can and should make us mindful of the transcendent realm of the infinite Lord. Yet it need not. Many are satisfied with the "richness of life" offered by aesthetic stimulation which by its nature can make few self-consuming demands.

In distinguishing between the aesthetic and the religious, Kierkegaard's thought is useful. Highly regarded by the present intellectual establishment as the founder of existentialism, Kierke-

gaard was a professing Christian. He is a useful ally for Christians in the arts who would explain their position to colleagues. Although I have reservations about some aspects of his thought, his distinctions between the aesthetic, the ethical and the religious are in the best tradition of Christian thought.

According to Kierkegaard (here I greatly oversimplify his analysis), the aesthetic sphere of life is to live for oneself, to orient oneself according to pleasures of various kinds, whether sensual or highly refined. Many devote themselves completely to this ego-centered quest for personal pleasure; ultimately, though, the aesthetic realm alone proves unsatisfying and leads to despair.

The next realm is the ethical. Here one lives no longer for the self but exclusively for others. Ethical acts involve self-sacrifice, putting another's pleasure, another's good, above your own. However noble life is in the ethical realm, this too, followed honestly, ends in despair. Living for the other person involves contradictions, impossibilities and failures. In other words, human beings cannot perfectly fulfill the moral law.

At this impasse a person may move on to the third realm, the religious. Here one lives in conscious dependence on the grace of God. As in the aesthetic realm, the person only receives. As in the ethical realm, the person lives for others; only this time it is, above all, living for the gracious God. Whether one accepts the various complexities of his analysis, Kierkegaard's paradigm is simply an application of the gospel: we cannot find salvation through the mere pursuit of sensations (the aesthetic), nor even by good works (the ethical), but only by grace through faith (the religious).

Religion, the gospel, does not deny the aesthetic realm any more than it denies the ethical realm. Just as religion affirms moral values, so it can also affirm aesthetic values, although neither can be the absolute basis for life. Each has its place in God's will—personal pleasure no less than moral action—but apart from God's

will they can result in the tyrannies of egoism, sensuality or legalism. The religious sphere gives each its place, as long as the three are not confused with each other.

Form and Content

Another useful distinction in combating idolatry is between content and form. The "artfulness" of a work—its method and technique, its genre, the qualities that give it an aesthetic impact—has to do with form. Although there are perhaps examples of art that are "pure form," for example, music or abstract art, most art also conveys some sort of content or subject matter; that is, it is about something. It conveys some kind of perception, idea, world view or experience that exists also outside the work of art. A landscape painting, for example, may depict mountains, trees, a village. Such things, perhaps the specific location, exist beyond the painting. In addition, it may be expressive of a particular mood, such as melancholy or exaltation, which may also exist apart from the particular painting that evokes that feeling. It may convey, consciously or unconsciously, a philosophy or world view; the artist's assumptions about nature may be evident from his painting, or his reactions to the assumptions and trends of his time.

All of this is the content or subject matter of his painting which can be stated, discussed and written about in propositional form. The design of the painting, its array of mass and color, its effectiveness, its degree of abstractionism or realism, its artistic "school" are matters of form. Although the relation between content and form is very complex, the two are in principle quite distinct. We may aesthetically appreciate a work of art, deriving pleasure, satisfaction and a feeling of admiration for the artist's skill, without agreeing with its content. The modern agnostic who reads Dante cannot help but be overwhelmed with his artistic power even though he may stridently oppose medieval Christianity. Converse-

ly, I find myself enjoying and appreciating the works of, say, Walt Whitman, while holding his philosophy to be profoundly and consistently wrong. How is this possible? Simply, I would argue, because the aesthetic impact of a work, its formal qualities, is distinct from the intellectual or referential qualities of the work, its content.

It is true that one is usually not possible without the other. Aesthetic form presents its content in a powerful and persuasive way. A novel by Sartre is a far more effective testimony to existentialism than his philosophical discourses, since in addressing the imagination rather than the understanding it comes closer to its readers' lives. This is exactly why Christian artists who are explicit about their faith are so important in the church's mission. That the medium and the message are distinct, contrary to McLuhan's thesis, is not to deny their interplay or even, in some cases, their fusion. It means that whether a work is "Christian" or "non-Christian" has to do with its content, not its form.

As subsequent chapters will argue, Christian artists may in principle use any style, any set of techniques, any type of artistic expression to express the content of the gospel. Not that every formal device would be aesthetically appropriate for a particular subject, nor that Christian artists need to be always expressing the gospel. That is not the sole glory of art. But they can follow the most contemporary of forms, if they want to and are careful about the content that is being conveyed, without fear of compromising their faith. Conversely, art can be used in the service of false, idolatrous religions. In this case it is not the aesthetic form that is necessarily to be rejected, but its content.

Archaeologists have seen similarities between the descriptions given in the Bible of the objects used in worship of the Lord—the altars, the design of the Temple, its cultic objects—and those used in pagan religions. A horned, gilt altar (the form) may be used for the worship of Baal or the worship of the Lord (the content). The

idolatry consists in its use, its content. The golden calf was different from the twelve bronze oxen supporting the cleansing "sea" of the Temple not in form but in meaning (2 Chron 4:4). The former was honored as God; its content was that Israel would conform to the kind of religion all of the other peoples of the time followed, a made-up mythological religion, worshiping a god under human control, which in practice means a god that is subhuman. The twelve oxen, on the other hand, symbolize the twelve tribes of Israel; they support the huge laver that was used for ceremonial cleansing, typologically looking forward to Christian baptism, to the cleansing of the Word of God as it rests upon the foundation of the apostles and the history of Israel (Eph 2:20). A Christian artist, if zealous of biblical truth, may employ any form without fear of committing Aaron's sin.

Caring for the Audience

It is perhaps easier for artists to distinguish between form and content, between the aesthetic and the religious, than for their audience. Artists know their work too well to make false claims for it.[2] Often artists find themselves pressured by their audience to create works that will be misused, testifying to a world view or a way of life that from the Christian perspective is false, sinful or idolatrous. This pressure may come from artistic peers, teachers, publishers or exhibitors, or, what is worse, the "paying public" who will only buy or support what they find congenial. In a non-Christian world there is not always a market for art that does not conform to the prevailing intellectual trends, as Christianity, indeed, must not.

Aaron stands, then, as a negative example for Christian artists. Aaron was a man of faith, chosen and called by God (Ps 105:26; Heb 5:4), the witness, spokesman and instrument of God's power through Moses (Ex 4:15-16), entrusted with his descendants with the ministry of the priesthood (Ex 28). Why did he make the golden

calf? How did he become party to apostasy? The answer is simple: As an artist, he pandered to his audience. He gave in to the pressure. The people insisted on an idol, so he took their gold and made them one.

Today artistic integrity, let alone spiritual integrity, is often compromised by the marketplace. One creates not necessarily what one wants to create but what sells, or what is being published, presenting something that will be approved of by peers rather than perhaps what one really believes. In the day of "the obligatory sex scene," when, of all things, nihilism has become "the establishment," those who seek to portray some other values, some other world view, often feel either that they must remain unpublished or unknown, or that they must compromise, giving the audience what it wants.

Aaron acquiesced. And, when explaining it to Moses, he blamed the people for what happened. The craftsman disclaimed all responsibility: "Let not the anger of my lord burn hot; you know the people, that they are set on evil. For they said to me, 'Make us gods. . . . ' And I said to them, 'Let any who have gold take it off'; so they gave it to me, and I threw it into the fire, and there came out this calf" (Ex 32:22-24). It simply "came out"; he had nothing to do with it. And yet Aaron's sin was not simply making a statue. His sin was caring too little for his audience, having insufficient love for the people. "And Moses said to Aaron, 'What did this people do to you that you have brought a great sin upon them?' " (Ex 32:21).

The artist must care for his audience enough to avoid corrupting them, to not bring sin upon them through false or salacious content, even at the expense of popular success. Christian artists should pursue aesthetic goals and test their message and its effect by the Word of God.

4
The Works of Bezalel: Art in the Bible

HAVING CALLED AND EMPOWERED BEZALEL WITH THE GIFTS FOR ART, the Lord specifies what sorts of art he desires for the tabernacle and, later, for the Temple. In chapter after chapter, the Bible describes God-ordained works of art. Francis Schaeffer has observed that the making of the tabernacle involved "almost every form of representational art that men have ever known."[1] Remembering the danger of idolatry exemplified in the work of Aaron, we can see in the prescriptions for the tabernacle and the Temple specific, positive examples of how various types of art—abstract, representational and symbolic—can function to the glory of the one God and the benefit of his people.

Abstract Art

When we read the scriptural accounts of the tabernacle, the Temple and their furnishings, the imagination soon fails. The details of

wooden forms inlaid with gold and bronze, the "ten curtains of fine twined linen and blue and purple and scarlet stuff" (Ex 26:1), the gold filigree and twisted chains, become difficult to picture in our minds. The colors and forms are dazzlingly various, the textures and shapes incredibly complex. Much of what Bezalel made can perhaps best be appreciated in terms of abstract art, that is, of pure design, which perhaps most essentially represents the "artfulness" of art.

By abstract art I mean art that represents nothing outside of itself. It consists of forms and colors arranged in designs. Much of what is now called abstract art is actually an intellectual statement—studies in randomness, statements of the meaninglessness of life, experiments of "minimal" art, jokes by egotistical artists on their public—although much still shows concern for pure design in the older sense. When I refer to "abstract" art, think not so much of Jackson Pollock but of a Persian tapestry or the margins of a medieval illuminated manuscript. The designs are beautiful—highly ordered, incredibly intricate. They represent nothing outside themselves, but are breathtaking in themselves, just as a mountain or a flower represents nothing outside itself and is beautiful.

Much of the tabernacle and Temple is art of this type. Consider, for example, Jachin and Boaz, the two freestanding pillars that were to stand just outside of the Temple:

He cast two pillars of bronze. Eighteen cubits was the height of one pillar, and a line of twelve cubits measured its circumference; it was hollow, and its thickness was four fingers; the second pillar was the same. He also made two capitals of molten bronze, to set upon the tops of the pillars; the height of the one capital was five cubits, and the height of the other capital was five cubits. Then he made two nets of checker work with wreaths of chain work for the capitals upon the tops of the pillars; a net for the one capital, and a net for the other capital. Likewise he made pomegranates; in two rows round about

upon the one network, to cover the capital that was upon the top of the pillar; and he did the same with the other capital. Now the capitals that were upon the tops of the pillars in the vestibule were of lily-work, four cubits. The capitals were upon the two pillars and also above the rounded projection which was beside the network; there were two hundred pomegranates, in two rows round about; and so with the other capital. He set up the pillars at the vestibule of the temple; he set up the pillar on the south and called its name Jachin; and he set up the pillar on the north and called its name Boaz. And upon the tops of the pillars was lily-work. Thus the work of the pillars was finished. (1 Kings 7:15-22)

These gigantic bronzes, standing about 33½ feet high with a diameter of about 5½ feet, are an example of abstract art. As Schaeffer has observed, "they supported no architectural weight and had no utilitarian engineering significance. They were there only because God said they should be there as a thing of beauty."[2]

This was not the kind of sculpture many people prefer. It was not of Moses, it was not an equestrian statue of Joshua or an inspiring depiction of David and Goliath. Mimetic, representational statues were prominent in pagan temples and in pagan art, as in that of the Greeks to whom we owe much of our aesthetic prejudice. When such "realistic" statues were placed in the Temple, they, and the religious values they conveyed, were condemned as the most horrible abominations (2 Kings 21:7; see also, in the Apocrypha, 1 Maccabees 1:54 for classical art—probably a Phidian Zeus —in the Temple). Instead, the sculptured pillars were examples of imposing and intricate design—"nets of checker work with wreaths of chain work" whose only purpose was glory and beauty (Ex 28:2).

This is not to say, however, that the pillars or abstract art in general is totally without meaning, as is evident in the names or titles given them: Jachin means "God establishes"; Boaz means "He comes with power." The qualities of the bronze monoliths,

their stability and their imposing presence as they stand in empty space, strong but supporting nothing that can be seen, recall the establishing work, the activity and power of God. They do not represent God, but rather their qualities call to mind and illustrate the work of God, how he establishes, how he comes with power. Abstract art can present "abstractions"—power, order, beauty, glory—without representing a creature within the world, which can sometimes be seen as the whole focus or source of the meaning.

There is among Christians today a great prejudice against abstract art. Certainly, much of modern art is dominated by non-Christian assumptions, as H. R. Rookmaaker and others have shown.[3] Still, nothing can be wrong per se with nonrepresentational art. That is, in fact, the type of art favored by the ancient Hebrews. This is evident throughout the Jewish tradition, which has generally rejected representational art but has remained extremely creative. Josephus records how the Jews rioted when Pontius Pilate brought into Jerusalem Roman ensigns that included a bust of Caesar on them. These were not used for religious purposes, nor did the Jews object on purely political grounds, since the earlier nonrepresentational Roman ensigns which Pilate's predecessors used did not occasion such an uproar.[4] That a human face was on the Roman coins was scandalous. Native Jewish ensigns, coins and other artifacts would be adorned with floral patterns, geometric designs and symbols like the Menorah, and all skillfully worked and aesthetically pleasing.

Consider the art of Islam, whose radical understanding of the prohibition of images expressed in the Second Commandment rejects all representational art, but has nourished a centuries-old tradition of the most sublime abstractionism, full of color, complexity and order, depicting nothing outside its own beauty and design. Again, arranging color and form into aesthetic designs—practicing abstract art—is "safe." Representational art should be

the style that makes those who believe the Scriptures the most uneasy.

Representational Art

The pillars Jachin and Boaz bore carvings of pomegranates and lily-work. The sacred lampstands were to feature almond blossoms (Ex 25:31-35); the Temple's ten stands of bronze were engraved with lions, oxen and palm trees (1 Kings 7:2-37). Not only were representations of nature prominent in the tabernacle and Temple, but representations of supernatural beings, the cherubim, were everywhere: carved on the furnishings, woven into the veil of the Holy of Holies (Ex 26:31), and sculpted on the central shrine of the invisible God, the ark of the covenant itself (1 Kings 7:29, 36; Ex 26:31; 25:18-20). Clearly, representational art is also acceptable to God.

The art of the Temple specifically avoids representing God himself, in marked contrast to the art of the pagan temples; instead, the emphasis is on the works of God, the designs that he made in creating the universe. At the creation, of course, the primal moment of artistry, there is no question of being representational. God made everything—its color, its form, its structures—according to his will (Rev 4:11). He is the original abstract artist. Without models or patterns, God made all things visible and invisible from nothing. He invented colors, the laws of geometry, the shapes of animals. His works are so various and, we are just now learning, so intricate that it is staggering.

Consider the structure of an atom, the properties of light, the existence of such things as quasars, amoeba, flowers, the human body, blue whales—each incredibly complex and intricately crafted. Wherever we look, on whatever scale, whether it be the vast, seething, lifeless world of the planet Jupiter or the complicated world teeming with life that exists in a drop of water, whether it be as

unimaginably huge as the Spiral Nebula or as unimaginably small as the DNA molecule, we find the caring creativity of the Lord that is lavished on all of his works (Ps 104). Moreover, the plentitude and beauty of the works of God are all around us. Annie Dillard observes that God is infinitely more imaginative than we are: "You are God. You want to make a forest, something to hold the soil, lock up solar energy, and give off oxygen. Wouldn't it be simpler just to rough in a slab of chemicals, a green acre of goo?" Instead, God creates dazzling intricacy with overwhelming fullness. "A big elm in a single season might make us as many as *six million* leaves, wholly intricate, without budging an inch; I couldn't make one."

> We have not yet found the dot so small it is uncreated, as it were, like a metal blank, or merely roughed in—and we never shall. We go down landscape after mobile, sculpture after collage, down to molecular structures like a mob dance in Breughel, down to atoms airy and balanced as a canvas by Klee, down to atomic particles, the heart of the matter, as spirited and wild as any El Greco saints. And it all works. "Nature," said Thoreau in his journal, "is mythical and mystical always, and spends her whole genius on the least work." The Creator, I would add, churns out the intricate texture of least works that is the world with a spend-thrift genius and an extravagance of care. This is the point.[5]

When God is understood as the primal artist, depictions of his works can be a means of honoring him, of recognizing and imitating those forms that he chose to create. In fact, it is a measure of human obtuseness, emanating no doubt from the Fall, that we tend to ignore God's works with all of their intricacy and beauty simply because they are so commonplace. One of the functions of art is precisely to increase our awareness of the beauty and significance of what we normally ignore because it is so familiar to us. By lifting up an everyday object, removing it from its normal context, an artist can point out to us an object's true nature and value.

We always have oranges at our house, but it was not until I saw a painting of some oranges that I really noticed and appreciated their beauty—the brightness of their color, the complex texture of an orange peel and its fruit, the way light shines on them.[6] Art can thus be precisely a means of ascribing "to the LORD the glory due his name," as the greatness of the Lord's works is uncovered and disclosed (Ps 96:8).

Not only is nature, particularly plant life and animals, featured in the art of the tabernacle and Temple, but the supernatural is as well; in the figures of the cherubim, spiritual beings are represented by means of tangible, material images. Not at all like the winged babies of conventional religious art, the cherubim are angelic beings whose spiritual form when manifested to the senses overloads our finite imaginations. Ezekiel records that "this was their appearance":

> They had the form of men, but each had four faces, and each of them had four wings. Their legs were straight, and the soles of their feet were like the sole of a calf's foot; and they sparkled like burnished bronze. Under their wings on their four sides they had human hands. And the four had their faces and their wings thus: their wings touched one another; they went every one straight forward, without turning as they went. As for the likeness of their faces, each had the face of a man in front; the four had the face of a lion on the right side, the four had the face of an ox on the left side, and the four had the face of an eagle at the back. Such were their faces. And their wings were spread out above; each creature had two wings, each of which touched the wing of another, while two covered their bodies. And each went straight forward; wherever the spirit would go, they went, without turning as they went. . . . And the living creatures darted to and fro, like a flash of lightning. (Ezek 1:5-14)

Ezekiel's vision of such beings is unimaginable; they are apparently revealed to him from all dimensions, from four sides at once,

and they are simultaneously covered by their wings and disclosed to him in detail. Such a spiritual encounter, which should help keep us from anthropomorphizing the heavenly realm, is impossible to visualize fully or to represent pictorially.

Yet Bezalel was commanded to adorn the tapestries of the tabernacle "with cherubim skilfully worked" (Ex 26:1). No doubt they were greatly simplified and stylized, accommodated to the capacities of limited human beings. Solomon's Temple included two colossal statues of cherubim, each with two seven-foot wings that stretched the whole breadth of the Holy of Holies (2 Chron 3:10-13). More significant were God's instructions for the ark of the covenant:

> *And you shall make two cherubim of gold; of hammered work shall you make them, on the two ends of the mercy seat. . . . The cherubim shall spread out their wings above, overshadowing the mercy seat with their wings, their faces one to another; toward the mercy seat shall the faces of the cherubim be. And you shall put the mercy seat on the top of the ark; and in the ark you shall put the testimony that I shall give you. There I will meet with you, and from above the mercy seat, from between the two cherubim that are upon the ark of the testimony, I will speak with you of all that I will give you in commandment for the people of Israel. (Ex 25:18-22)*

The significance of these details is heightened, again, by Ezekiel's vision. Above the real cherubim he glimpsed something even more staggering:

> *And above the firmament over [the cherubim's] heads there was the likeness of a throne, in appearance like sapphire; and seated above the likeness of a throne was a likeness as it were of a human form. And upward from what had the appearance of his loins I saw as it were gleaming bronze, like the appearance of fire enclosed round about; and downward from what had the appearance of his loins I saw as it were the appearance of fire, and there was brightness round about*

him. Like the appearance of the bow that is in the cloud on the day of rain, so was the appearance of the brightness round about. Such was the appearance of the likeness of the glory of the LORD. And when I saw it, I fell upon my face. (Ezek 1:26-28)

Such a theophany was not rendered artistically on the ark, of course. Above the cherubim and the mercy seat Bezalel made nothing, although from that space God's presence and God's word were manifest in a special way (Ex 25:22). The tabernacle was "a copy and shadow of the heavenly sanctuary" (Heb 8:5). The ark represented in art the actual court of God, which, through grace, he established on earth with his chosen people, dwelling in their midst in a desert tent. The ark as imaging the very presence of God speaks to us also of Christ, the incarnate God, who "became flesh and dwelt among us," who "tabernacled" with us according to a literal translation (Jn 1:14).

The point is, art is able to represent and convey spiritual realities. The highest and most ineffable of which, the very presence of the Deity with his heavenly hosts, God commissioned Bezalel to represent in the ark of the covenant with its mercy seat. Certainly, then, spiritual truths are fit subjects for an artist.

The concept of "accommodation" is helpful here. The figures of the cherubim crafted by Bezalel were not identical in appearance to those experienced by Ezekiel, which defy static pictorial depiction. The carvings of the cherubim according to Ezekiel showed them with only two faces in a two-dimensional bas-relief (Ezek 41:18-19). Ezekiel's vision itself was an accommodation on the part of awesome spiritual entities to a limited being bound by merely physical senses.

Ezekiel's descriptions are necessarily full of similes and comparisons to earthly analogues. In the theophany that he experienced, Ezekiel dared not say that he was looking on God; rather, he was seeing "the appearance of the likeness of the glory of the LORD"

(1:28). Here there are four levels removed, established by concentric prepositional phrases, from the Godhead. Throughout his description he sees not a throne but "the likeness of a throne"; the phrase "as it were" is repeated over and over again. Gazing upon "the glory of the LORD," he perceives "a likeness as it were of a human form"; what he is perceiving is the image and likeness that God shares with human beings from the creation (Gen 1:26) and, more profoundly, the Second Person of the Trinity, Jesus Christ, whose human nature is ever subsumed into the Godhead.

Ezekiel is seeing something real but accommodated to his limited human faculties. No mortal can look on God and live (Ex 33:20). The merest glimpse is enough to make Ezekiel fall on his face. Yet the infinite God deigns to reveal himself to mortal flesh, making himself known in tangible form fully and completely in Jesus Christ, but also in "copies and shadows" fitted to the different capacities of human beings. Human artists may likewise represent spiritual reality, expressing the invisible in terms of the visible (see Rom 1:20). Such representations are never exhaustive of their subject matter; rather, they tend to accommodate themselves to what the human imagination is capable of.

Thus representational art is definitely sanctioned by Scripture. The difference between the images made by Bezalel and those forbidden by the Second Commandment is that the former communicate what God reveals, not what humans invent. They do not receive worship but point beyond themselves to the true object of worship. They do not pretend to "contain" the infinite God, only to praise him and communicate his reality to others. The realm of nature and the realm of heaven itself are fit subjects for representational art.

Notice that representational art does not necessarily mean "photographic realism," itself largely a product of scientific materialism. To paint the cherubim as described by Ezekiel in hard-

edged visual detail in a style of naturalistic realism would be aesthetically ludicrous and theologically misleading, turning them into science fiction monsters rather than spiritual entities whose shifting appearances point to their unfathomable transsensory dimensions. A more abstract or expressionistic style would be more appropriate, capturing their mystery and awesomeness. Even paintings of the natural world need not be "photographic." Francis Schaeffer observes that some of the pomegranates that were to adorn the garments of the priest were to be blue, a color that never occurs in natural pomegranates.[7] One thinks of Chagall and Matisse. Painting an apple blue instead of red, depicting nature in new ways by experimenting with color and form, helps us see the object in a new way, not as inevitable and ordinary but as the creative, even arbitrary, handiwork of God.

Artists have always enjoyed painting still lifes and landscapes; paintings of flowers, fruits, animals and trees seem universal in both Western and Eastern art. There is also the impulse to go beyond nature, whether to create blue pomegranates or to represent the most sublime spiritual truths in visible form. Both kinds of art, as well as art that represents nothing at all, had their place within the Holy of Holies, commanded by the very Word of God.

Symbolic Art

Art can adorn by virtue of its beauty of design; it can represent entities outside itself. It can also teach by embodying and communicating propositional knowledge. That is, it can be symbolic. Such art was also prominent in the tabernacle and the Temple, where its purpose was not only to glorify God but also to build faith in the worshipers.

Consider again the design of the central object in Israelite worship, the ark of the covenant. A gilded wood chest about four feet long, two feet wide and two feet deep, it contained the tablets of

the law, an urn of manna and Aaron's rod (Heb 9:4). On its lid of pure gold, called the mercy seat, the two cherubim faced each other, looking down toward the mercy seat (Ex 25:17-21). Once a year, on the Day of Atonement (Yom Kippur), in a solemn drama the high priest would enter the Holy of Holies, the ark obscured by a cloud of incense, and sprinkle the blood of the scapegoat on the mercy seat as atonement for the sins of the people (Lev 16).

What is symbolized here is the very gospel itself, the central mystery of salvation through which the Old Testament saints and we ourselves are reconciled to God. Coming between the presence of God and the tables of the law, broken by human sin, is the blood of atonement. The cherubim look down and see not the law but the sacrificial blood, which covers all sins. These symbols look ahead to and have their fulfillment in Jesus Christ, the Lamb of God who takes away the sin of the world:

> *When Christ appeared as a high priest of the good things that have come, then through the greater and more perfect tent (not made with hands, that is, not of this creation) he entered once for all into the Holy Place, taking not the blood of goats and calves but his own blood, thus securing an eternal redemption. . . . How much more shall the blood of Christ, who through the eternal Spirit offered himself without blemish to God, purify your conscience from dead works to serve the living God. (Heb 9:11-14)*

On Yom Kippur it was not the blood of the goat that took away sins (Heb 10:4); rather, the symbolism of the ark, the ritual and the sacrifices were designed to provoke faith. As "copies of heavenly things," they were to instruct and prepare God's people for the fulfillment of the promise that was to come in Christ. The Old Testament saints were saved, never by works, but by grace through faith (Eph 2:8). Christ's atonement covered them also, although they knew it only by glimpses, prophecies and symbols.

Many other Old Testament artifacts were also symbolic. The

"molten sea" supported by the twelve oxen has already been men-
tioned as symbolizing the cleansing of the Word of God, looking
forward to baptism. The table of shewbread, the "bread of the
Presence," calls to mind Holy Communion and all that it means.
The golden lampstand, the lavers, the altars, all have a teaching
purpose besides being beautiful and ritually functional. The holy
garments of the priest, for example, were to be adorned with twelve
different jewels—sardius, topaz, carbuncle, emerald, sapphire,
diamond, jacinth, agate, amethyst, beryl, onyx, jasper—all set in
gold filigree, each carved with the name of one of the tribes of Israel.
"So Aaron shall bear the names of the sons of Israel in the breast-
piece of judgment upon his heart, when he goes into the holy place,
to bring them to continual remembrance before the LORD" (Ex 28:
29). Whenever Aaron ministered before the Lord, he did so on be-
half of all God's people. Not only, though, do the jewels symbolize
the tribes being brought before God, but they indicate how God
feels toward his people: each tribe is a precious stone, different
from each other, but each full of value and light as with the re-
deemed in heaven (Rev 21:9-21).

Art has the capacity, then, to render ideas and in doing so to
communicate them powerfully and richly. Not all art is symbolic;
it is not supposed to be. A painting of a tree need represent only
a tree, which as God's creation is meaning enough. An intricate
design—think of the gold filigree on the priest's breastplate or
the skillfully worked tapestries of the tabernacle—need have
no significance other than its own beauty which, as God's gift,
is reason enough for its existence. But art also can embody a mes-
sage, even the very gospel of our Lord. To be sure, the symbol-
ism can go awry; it can communicate false messages as well as
true. Again, the message must be tested by extra-aesthetic means
—for Christians, whether it conforms to the Word of God. Never-
theless, the symbolic dimension of art is a profound and God-

established means of communication.

Art and Culture

The Metropolitan Museum of Art in New York City has excavated and restored on its grounds an ancient Egyptian temple. Walking through it, thinking about Moses and the children of Israel, I noticed with a thrill of recognition that this temple, built to a pagan god, consisted of three inner chambers, exactly like the plan of the tabernacle and the Jerusalem Temple. In fact, the structure of the Temple was common throughout the ancient world, as were portable "arks," tents of worship, certain details of ritual and even what seem to be figures of cherubim. Archaeological research and Old Testament scholarship have uncovered many parallels in Hebrew life and worship to various Egyptian, Syrian and Canaanite practices. Liberal theologians sometimes make much of these connections, using them to minimize the uniqueness of God's special revelation and relationship to the Jews. The point, however, has to do with the relationship between art, culture and religion. Art is, by its very nature, open to and a function of human culture, so that sacred truths can be expressed through a wide variety of culturally conditioned art forms.

Art, by the Second Commandment, is not sacred. Its meaning or use may be sacred, but art should never be thought of as sacred in itself, or of containing or limiting the infinite God. Solomon understood this point as he dedicated the Temple: "Behold, heaven and the highest heaven cannot contain thee; how much less this house which I have built!" (1 Kings 8:27). In fact, when the people began to use the Temple and the ark in an idolatrous, faithless way, God ordained their destruction.

The artifacts were made by and for human beings. Therefore, they would by accommodation accord with the assumptions and the imagination of the people who would be using them. When

the Hebrews thought of a temple, they thought of three-part divisions, as in all the other temples they had seen. That is fine: God's Word can be heard in a building with that sort of architecture. The Hebrews could not build a Gothic cathedral. They had neither the technology nor the culture for it; they would not have understood it. Gothic cathedrals, by the same token, are not sacred either, although, again, God can use them to make himself known. The Canaanites, on the other hand, did believe in sacred places and sacred images.[8] The Philistines identified the ark as God (1 Sam 4:7); and what happened to the image of Dagon was happening to Dagon himself (5:1-7). But in the biblical view, since God alone is sacred, the special places and the styles of art do not, in a certain sense, matter.

Thus, when the Temple was to be built, Solomon simply turned to the best artists that he knew, the Phoenicians: "For you know that there is no one among us who knows how to cut timber like the Sidonians" (1 Kings 5:6). So Solomon sent to Hiram, the king of Tyre, asking him for material and workmen. Notice that Solomon, wishing to glorify God, was concerned first with excellence, not doctrinal purity in the artists. Hiram, although complimentary about Israel's God, was not part of God's chosen people and almost certainly was not a believer (see 1 Kings 11:5). The actual craftsman sent by King Hiram, the counterpart to Bezalel, was part Hebrew, on his mother's side, and no doubt was a believer in the God of Israel. In the words of King Hiram's letter to Solomon,

> Now I have sent a skilled man, endued with understanding, Huram-abi, the son of a woman of the daughters of Dan, and his father was a man of Tyre. He is trained to work in gold, silver, bronze, iron, stone, and wood, and in purple, blue, and crimson fabrics and fine linen, and to do all sorts of engraving and execute any design that may be assigned him, with your craftsmen, the craftsmen of my lord, David your father. (2 Chron 2:13-14)

Huram-abi, or Hiram as the name is elsewhere rendered (1 Kings 7), must have known the Lord through his mother, despite his pagan environment. Nevertheless, the art of the Temple must have been Phoenician, in accordance with the training that he had received. Scripture specifically says that Solomon set the aliens in the land to work on the Temple, both as laborers and overseers (2 Chron 2:17-18); these were remnants of the Canaanites who were definitely not believers (Josh 23:7; Judg 2:2-3). Thus, the art of the Temple, open to the culture of its day, was no doubt similar to buildings of the Phoenicians and other peoples of the land. Nevertheless, the Temple and its art pleased God and was made an instrument of his purpose (2 Chron 7:12-16).

This point is important for Christians involved in the arts. Because a painter is not a Christian, that does not mean that his paintings cannot be enjoyed or even imitated by Christians. To be sure, any thematic content must be scrutinized very critically through the lens of Scripture, but art as art is essentially neutral. That Picasso was not a Christian does not mean that he was not a great artist, nor does it mean that Christians are not free to appreciate or emulate his works. To think otherwise may be to overvalue or sacralize art, to ascribe to it a significance it must not assume.

Was the person who made my shoes or cooked for me in a restaurant a Christian? Or the scientist who discovered penicillin? Or Beethoven? I can never know. I should pray so for the sake of the person, but even if he or she was not a Christian, I am not harmed spiritually by my clothing or my meal, by receiving my medicine or listening to a symphony. Art is a part of human life like food, clothing, politics, scientific knowledge and social customs. All of these are valuable gifts of God, essential parts of our humanity, created by sinners in need of Christ's redemption who may or may not know him. For aesthetics, although not for theology, a Christian may "go to the Sidonians."

Always a function of human culture rather than divine revelation, no particular style or type of art ought to be sacralized or made into an absolute.[9] The history of art shows continuous change, and this is partially because cultures change through technology, the facing of new problems and the accumulation of different kinds of ideas and experiences. Art also has an inherent tendency to change. If art exists to heighten experience, to help us notice and appreciate what we are so used to that we ignore, an artistic style itself will tend to become so familiar that it no longer startles us with fresh perceptions. It fades into the background, into the decor. We no longer pay any attention to it. So art must be in a continuous state of change for it to remain alive and effective. Unlike human culture, Jesus Christ does not change (Ps 90; Heb 13:8). The infinite God, who is never limited by finite forms or human works, can bear his testimony through a multitude of forms, as the history of religious art from the Byzantines to Rouault makes strikingly clear.

It follows therefore that Christians need not be overly scrupulous in regard to types of art. Abstract, representational and symbolic art are all given prominence in the Scriptures. Certainly the content of art, the underlying assumptions and messages that are conveyed, must be examined with wariness and scriptural discernment. Antiscriptural content is not always merely an intellectual idea that can be analyzed and dismissed. Scorn for "ordinary people," moral permissiveness, the habit of mockery, self-pity, voyeurism, the sense of how terrible life is—all these attitudes and feelings can be more spiritually poisonous than any propositional statement, and they can be absorbed easily through art.

Questions of form, however, are basically indifferent. Christians are free to pursue any formal mode of art that they find congenial. It is the secular aesthetes who take artistic movements and manifestoes with such dogmatic seriousness. Classical, romantic and realistic styles are all suited to Christian literature. Christian

painters can work with abstract art if they want to (actually, it is probably the safest for those who fear offending the Second Commandment), or they can be photographic realists or expressionists —whatever fits their talents and inclinations.

Since art is a function of history and culture, Christian artists should be aware of the contemporary context of their work. To be deliberately old-fashioned, simply reworking earlier styles that seem "more Christian," is an empty gesture. One style is not "more Christian" than any other; the result is to make one's work irrelevant and, worse, to imply that Christianity is outdated, a nineteenth- or sixteenth-century religion which some reactionaries stubbornly cling to, faith that has nothing to say to the twentieth-century imagination. Throughout the Psalms it is a *new* song that is to be offered to the Lord.[10]

Manifold Works

The tabernacle and the Temple offer concrete examples of artistry commanded and employed by God. Not only abstract, representational and symbolic art are given prominence, but also instrumental music (1 Chron 23:5; Ps 150:3-5), song (1 Chron 9:33; 15:16, 27) and dance (2 Sam 6:14; Ps 149:3; 150:4). When the Temple was completed, "the priests stood at their posts; the Levites also, with the instruments for music to the LORD which King David had made for giving thanks to the LORD—for his steadfast love endures for ever—whenever David offered praises by their ministry" (2 Chron 7:6). Here the purpose of the instruments is to give thanks to God for his steadfast love. That musical instruments, apart from any vocal accompaniment, are a means of nonverbally "giving thanks" is a profound statement of the religious value of art. Here art is a human response to God's blessings, an offering of beauty to the Designer and Creator of existence, the ultimate source of all blessing and all beauty.

This Scripture indicates moreover how the audience is involved. When the trumpets, psalteries, harps and cymbals were playing, David "by their ministry" could also "offer praises." The picture is of a person praising God by means of the music performed by others. Music is described as a ministry. What is true here of music is true of all the arts. They can be a response to God and a ministry to other human beings, valuable both as an expression of the artist and as a catalyst for the audience.

There are many types of aesthetic forms. What Bezalel made for the tabernacle and Hiram the Sidonian made for the Temple were not, of course, museum pieces. The practice of isolating beautiful objects away from their contexts in ordinary life is a modern invention and would be incomprehensible to someone like Bezalel. Still, there is a connection between the works of Bezalel and those of artists in the high art tradition of our modern culture. In both cases great skill is expended in making aesthetic designs. Whether these designs are made to function in worship or to be contemplated in a museum, whether they are part of the texture of the culture or assigned a special status, the same gifts are involved in their making.

In the Old Testament God commanded that certain designs be created for glory and beauty, but they were also to communicate and to express in a compelling way his nature and love for his people. The aesthetic and expressive dimensions of art are thus sanctioned by Scripture. Moreover, nearly the whole range of the arts can be found in God's Word. This is true not only of the visual arts and of music; in literary art, poetry is exemplified in the Psalms, fiction in the parables, drama in the street theater of the prophets (2 Kings 13:14-19; Jer 19; Ezek 4:1-3). Again, Scripture is comprehensive, both in analysis and in scope. Just as God's works are "manifold" (Ps 104:24), that is, incredibly diverse, so are the works of human beings in his image. Each of them is made possible by God as part of his wisdom and grace.

5
The Heirs of Bezalel: The Tradition of Biblical Art

HAVING SURVEYED SOME OF WHAT THE BIBLE SAYS ABOUT ART, ITS value and its limitations, it will be helpful now to consider the actual practice of artists who would consider themselves in the biblical tradition. A detailed study of the biblical elements in Western art is out of the question here, of course, as is the sort of world-view criticism of artistic styles offered by H. R. Rookmaaker. Instead, I wish to show how, in fact, the Bible has always liberated art, how it has delivered it, for example, from static classicism and materialism and, even more deadly to art, from the sense that it is "sacred."

Monotheistic Art
As has been mentioned, our Western imagination is dominated by the Greeks. This can be sufficiently demonstrated by the preference of most people, including modern Christians, for representational

art, art as *mimesis*, a copy of something that exists in the outside world, a preference that the ancient Hebrews would certainly not share. The literal understanding of the prohibition against images in the Second Commandment did not, however, prevent art in traditional Hebraic culture; rather, it channeled God's gifts for art into other highly creative forms.

The difference between the Hebrew imagination and that of the Greeks, whose aesthetic assumptions we tend to share, can be seen in the poetic imagery of the Bible. Consider, for example, this passage from the Song of Solomon:

Behold, you are beautiful, my love, behold, you are beautiful!
Your eyes are doves behind your veil.
Your hair is like a flock of goats, moving down the slopes of Gilead.
Your teeth are like a flock of shorn ewes that have come up from the washing, all of which bear twins, and not one among them is bereaved.
Your lips are like a scarlet thread, and your mouth is lovely.
Your cheeks are like halves of a pomegranate behind your veil.
Your neck is like the tower of David, built for an arsenal, whereon hang a thousand bucklers, all of them shields of warriors.
Your two breasts are like two fawns, twins of a gazelle, that feed among the lilies. (4:1-5)

The images seem ludicrous. They lack unity and coherence. They mix the most extravagant and dissimilar metaphors which distract from and in no way describe what they are intended to represent. The difficulty one might have with the lines, however, is due entirely to the dominance in our classical imagination of the *visual*. Hebrew poetry, on the other hand, is not primarily visual, but appeals to a wide range of associations and senses.[1] When we read "your two breasts are like two fawns," we think of a visual picture, in this case, a jarring absurdity. When we realize that the image is not visual but *tactile*, the sensuousness of the description is nearly

overwhelming. The woman's cheeks do not *look* like pomegranates (what a horrible complexion that would be!) but rather the poet has made an image of fragrance and, even more sensuously, of taste.

Hebraic imagery also seems to be associative. The eyes-like-doves metaphor seems to refer to the timorousness but liveliness of the dove, to the woman's reticence and modesty, a sense also conveyed in the metaphor of the fawns. The hair like goats is another tactile image, with also the associations of richness and the pastoral life. The description of the teeth stresses, in another highly sensuous detail, their wetness, and in the characteristic Hebrew concern for how things are built, how they match each other, how even and well formed they are. The description of the neck refers to the way she stands, tall and aloof, proud, in a sense, and inaccessible. Throughout are allusions not only to her physical desirability but also to the overpowering attractiveness, nearly forgotten in the West but still present in other cultures, of chastity.[2]

Here is poetry of the highest order, describing the Shulamite, not one-dimensionally, but richly. The lover is attracted not only by what she looks like but by what she feels like when he touches her, what she tastes like, the associations of sheepfields and battle that she calls to his mind. Not only her appearance is described. Her character is suggested in lines of infinite richness and complexity. This is the eroticism not of the voyeur, who stresses the visual with its inherent distance and detachment from the sexual "object," but of the lover, with an overwhelming sense of closeness and intimacy.

There are other examples of the difference between the imagination in the Bible and that of the classical tradition. Notice that the Bible never describes what Jesus or anyone else looks like. Nor are there any extended spatial descriptions of "background," the leisurely description of setting and atmosphere common in Western fiction. Homer, by contrast, is full of the most vivid visual descriptions—"white-armed Hera," the red-gold hair of Achilles and the

detail of his immortal shield. Writers of the Western tradition have followed Homer, so that now one of the first tasks we ask of authors is that they orient us visually to their worlds so that we can "picture" the characters and their actions.

The Bible, however, works from different aesthetic assumptions. For the Hebrews, one relates conceptually to other people not by seeing them but by hearing them. Thus, to take a very important example, there is little talk of *seeing* God in the Bible. Such an experience is reserved for the future life ("Blessed are the pure in heart, for they *shall* see God" [Mt 5:8]). For the people of the Old Testament, a god one can see, such as the Canaanites had, would not be the real god but an idol. Although one cannot see God, one may hear God. God's *Word* is the basis for relationship with him. In fact, our imagination is so visual that people today have difficulty believing in a God they cannot see. We need to encourage them to "listen" to God, to read the Scriptures, expecting from God not a vision—again, note the terminology which like all "sight" involves distance and detachment—but an intimate, personal voice addressed to themselves.

The peculiarities of the Hebraic imagination may well be due to the prohibition of images, which tends to subvert purely visual, mimetic descriptions. This is not to say that the sense of sight is unimportant or that there are no visual images in the Bible, but simply that there is a different conceptual emphasis. Much of Scripture is difficult to picture, even the appearance of the tabernacle and the Temple with their consummate detail. The Hebrews were stressing how they were built and how the parts fitted together rather than what the unified whole looked like. The Greek mind, according to Thorleif Boman, tends to be spatial, with concern for unity and static form; this is apparent not only in art but also in the systematizing tendency of Greek logic and analysis, which has reached us through Plato and Aristotle. The Hebraic mind, on the

other hand, assumes that form is dynamic; it is iconoclastic, conscious that since God alone is absolute, all forms, human or natural, are subject to change.[3] Whereas the Greeks envisioned time spatially, in terms of cycles and moments that could be ritually reenacted, the Hebrews understood time historically, as a sequence that both had a beginning and looked toward an end. In this one respect we have followed the Hebraic imagination. Its concept of historicity, so different from that of mythical cultures such as the Greeks', has been taken over into Western culture fairly completely, as is apparent even in the aberrant philosophies such as Marxism, not to mention in art and in the rise and development of fiction.[4] The other elements of the Hebraic imagination—its nonvisual imagery, its dynamic form, its nonspatial thinking—seem also to have great potential, as yet unrealized, in inspiring new ways to imagine.

In the visual arts the prohibition of images led to abstractionism. This can be seen most clearly in the art of Islam, which in many ways has continued and extended the heritage of the radical monotheism of the Hebrews. In the mosaic work of the mosques, in their architecture and ornamentation, in the illuminated manuscripts and, most famously, in the tapestries, Islamic art presents a riot of colors and interlocking forms. The tiniest details, considered separately, seem anarchic in their bold colors and dynamic shapes, yet viewed from a distance those details are seen as contributing to a larger design that is harmonious, symmetrical and beautiful. There can be no better evocation of human life, with its freedom, variety and occasional appearance of random meaninglessness, all subsumed under the providence of God, who orchestrates all the seemingly contingent, accidental events of a person's life according to his saving design.[5]

Contemporary abstractionism pales before monotheistic abstractionism. The former is generally extremely simple, an expres-

sion of the curious interest in "minimal art." Modern galleries feature paintings of single shapes with few colors. Modern theorists are interested in the least common denominator of art, the barest, most "pure" gesture that can constitute a work of art. In contrast, the monotheists favor designs of lavish complexity and intricate splendor, art that exults in the superfluous. The black canvas in the gallery reflects the simplistic vision of despair, of nihilism; the Persian carpet reflects the aesthetic of the psalmist who rejoiced in the complex texture of God's multiple and abundant designs: "O LORD, how manifold are thy works!" (Ps 104:24).

The Early Church

With the coming of Christ and the preaching of the gospel to the Gentiles, the two streams of the Hebraic and the classical began to run together. At the same time, the momentous event of the Incarnation made a difference for the imagination of each.

"We preach," says Paul, "Christ crucified, a stumbling block to Jews and folly to Gentiles, but to those who are called, both Jews and Greeks, Christ the power of God and the wisdom of God" (1 Cor 1:23-24). To both the Hebraic and the Greek imagination, the message of Christ was staggering: "The Word became flesh and dwelt among us" (Jn 1:14). The Greeks knew about the *Logos*, the divine pattern that lies behind creation, which they conceived spatially and abstractly, a highly intellectualized philosophical principle. To say that the logos became flesh, became *matter*, a category which the Greeks in their fastidiousness despised, was unthinkable.[6] Some Greeks came to believe in the deity of Christ, but they taught that he was not truly a man in the flesh—the crucifixion was an illusion, for what is spiritual cannot suffer, and the resurrection was a purely spiritual event, not the literal rising of a three-day-old corpse. This is the heresy of Gnosticism, which the apostles and the early church battled, and which still survives in the

Christian Science movement and in the mainline academic theology that distinguishes "the Christ event" from the historical Jesus.

The Hebrews believed in the reality and value of the flesh. But to say that the Lord of Hosts, the one God, shares his glory and his being with anyone else was blasphemy. To identify the Messiah in any literal way with the one God, much less to assert that this God-man allowed himself to be humiliated and tortured to death, seemed at least a mass of impossible contradictions and, at worst, simple paganism. Christ might have been a great man, a prophet and moral teacher who died for the highest ideals, but he certainly was not God. This view is the heresy of Arianism, which historic Christianity has always condemned and which is still being taught in cults and some seminaries.

In Christ, God makes himself *tangible*. "That which was from the beginning, which we have heard, which we have seen with our eyes, which we have looked upon and touched with our hands, concerning the word of life—the life was made manifest, and we saw it, and testify to it, and proclaim to you the eternal life which was with the Father and was made manifest to us" (1 Jn 1:1-2). The "word of life" is not an intellectual abstraction, an invisible spiritual principle; rather, says John, we have seen it, we have heard it, we have touched it. The Incarnation means that God reveals himself in and by means of matter.

John, as he says, actually looked on, heard and touched the Son of God through whom all things were made. The realm of matter— Mary's womb, the Bethlehem stable, the swaddling clothes, the process of growing up, of working with one's hands, the lakes and fields of Galilee, the garden of Gethsemane, the lacerations of the flesh, physical torture, rigor mortis—has been penetrated by the presence of God himself. Moreover, Christ placed at the center of Christian worship two *physical* acts, one involving simple water

and one involving bread and wine, as uniquely proclaiming and manifesting his relationship to his people. The physical world and human senses are thus given a value they never had under the Greeks, a function anticipated in the Old Testament. They became means of grace.

The Middle Ages

This point is extremely important for art. The hesitancy to depict God through imagery seemed countered now by God himself, who deigned to manifest himself concretely in the flesh and form of a human being. The iconoclastic tradition continued to react to overt idol worship, but soon images and paintings were widely employed to focus the devotion of the faithful. For centuries, throughout Christendom art served religion. The art of the Middle Ages deals almost exclusively with Christianity: paintings of Christ as a child with his mother, images of Christ dying on the cross, mosaics of Christ *pantokratōr*, the risen, the glorified, all-powerful Lord. These sought to express the mysteries of the incarnation, atonement and resurrection in all their richness and tangibility. This was great art, addressing the great issues of form and content, integrating artistry and faith in a most satisfying way.

It has been observed how difficult it is to portray Jesus Christ as both true God and true man. Some depictions will tend to exalt Jesus in a way that stresses his divinity but that makes him seem remote; others will depict his humanity to the point that his uniqueness and divine essence are lost. Certainly, much medieval art falls into the first category, but much of it achieves and expresses the synthesis in a way that later artists have not. Here is a painting of a baby held by his mother with striking human affection. Yet this is not an ordinary baby. His face shows a striking maturity, and he is signing a blessing. His clothing and his mother's are simple, the dress of ordinary people of the time, yet around him is the glory

and lavishness of beaten gold. This is a child, yet more than a child. Or, consider the crucifixes: the pain they show is often gruesome, with distended rib cages and blood splashed everywhere—yet there is the gold, the singing angels, the cross growing into a tree of life. What is thus depicted is the very gospel itself: Christ as true God and true man, sacrificed in a death that means life to us.

Pure, nonrepresentational design also flourished in the Middle Ages, most notably in the illuminated manuscripts. Before the printing press, Bibles and other books of devotion were rare and precious. The Scriptures were copied by hand, a work that occasioned great artistry. The initial letters of the text were inlaid with gold leaf and were made to sprout leaves and tendrils that interlocked, as in Middle Eastern art, into the most intricate and splendid of designs. Just as Islamic art often begins in ornamentation and variations of letters of the Koran, this kind of calligraphic art was centered in devotion to the Word, to its very appearance and to the miracle that through signs scratched on paper God himself communicates to human beings. Not only were the letters adorned, but the margins were filled with pictures of Bible stories, ordinary life of the day, symbolic tableaux and, curiously, pictures that seem merely fanciful—comical looking creatures, half-human and half-animal, fabulous beasts, gargoyles that gape across the sacred page.

What place do these creatures of pure fantasy have in the art of Christendom? I would suggest that they represent a tradition that is both biblically grounded and historically important. The Second Commandment, again, warns of making "any likeness of anything that is in heaven above, or that is the earth beneath, or that is in the water under the earth" (Ex 20:4). If this restricts mimesis, the depiction of forms that already exist, it encourages creativity, the imagining of forms that do not exist. Making up a monster, rearranging physical details and structures of nature into new and

terrifying or amusing combinations, is the equivalent of abstract art, rearranging geometrical forms and colors into aesthetically pleasing combinations. It seems to me that the biblical tradition is uniquely hospitable to radical fiction, to purely fantastical works that make no pretense of being true, but that exist as what Tolkien describes as subcreations of the human imagination.[7] It was Plato, with his bias for the mimetic, who condemned imaginative poetry as "lies." The Second Commandment may reject what Plato would call art, but, in tempering the "realistic" impulse, it has room for "likenesses" of things that are not in heaven or earth or water. In fact, authors who have striven to be explicitly Christian in their work have often tended to favor the genre of fantasy. Consider Edmund Spenser, George MacDonald, J. R. R. Tolkien, C. S. Lewis, Madeleine L'Engle and others. Again, the Second Commandment did not so much forbid art as channel it into different directions, which proved both beautiful and highly imaginative.

If the Middle Ages represent a high point of Christian artistry, its fusion of aesthetics and faith was not without its problems. Theoretically, the use of art in prayer was simply to help the worshiper focus on the person of Christ. In practice, however, the icons themselves became adored. Some icons were seen as more sacred than others. Miracles were ascribed to particular images. They were honored, adored and prayed to. Many people seemed to live in a state of semipaganism, having replaced their statues of Diana for statues of the Virgin Mary but using them in exactly the same way. The religious use of art was not restricted to depictions of Christ and scenes from the Bible. The saints through their portraits were also venerated. Images of Mary were often more evident than images of her Son. Whereas Scripture teaches that "there is one mediator between God and men, the man Christ Jesus" (1 Tim 2:5), in practice there came to be many mediators, which obscured the sufficiency of Christ's sacrifice and the essence of the Christian

gospel. In other words, the fusion of aesthetics and faith, for all its richness, lent itself to idolatry.

The Reformation

The Reformation was an attempt to restore the gospel, which had been seriously obscured although never eradicated during the Middle Ages. It meant a rechanneling of art. The Reformers' attack on idolatry was important and need not be apologized for. The devotion to images, the use of art to promote false doctrines and the spirit of self-gratifying aestheticism even in the papal court were real obstacles to biblical faith and did indeed violate the Second Commandment. Some Reformers went further than others. Lutherans and Anglicans tended to reject only art that interfered with the message of Christ. Images of Mary and the legendary saints were removed with all of the attendant devotions and "works" associated with them; crucifixes, depicting the all-sufficient atonement for sin, were retained. Zwingli went further, insisting that all paintings and sculptures in church were idolatrous. Yet this did not mean that Zwingli was against art. One could just as well argue that the most extreme iconoclasts of the Reformation in actual effect opened the floodgates of art.

Walking through an art gallery, we can see the great, moving Christian masterpieces of the Middle Ages, the crucifixes and icons that make up a powerful aesthetic monument to faith. When we come to the works of the 1500s, however, the religious subject matter suddenly drops off. The Roman Catholic artists, especially of Italy, still paint Madonnas, but scenes of classical mythology, the legacy of Renaissance humanism, begin to dominate the gallery. The artists of the Reformation, the German, Dutch and Flemish painters, on the other hand, paint landscapes and portraits, scenes of common life and ordinary families. What the iconoclasts did was to secularize art.

The Reformed Church objected to the religious use of art but not to art as such. "I am not gripped by the superstition of thinking absolutely no images permissible," writes Calvin, "but because sculpture and paintings are gifts of God, I seek a pure and legitimate use of each."[8] Zwingli, the iconoclast, even permitted paintings of Christ as long as they were not in churches or offered reverence. According to Zwingli, "where anyone has a portrait of His humanity, that is just as fitting to have as to have other portraits. . . . No one is forbidden from having a portrait of the humanity of Christ."[9]

The rise of the art of portraiture in the Reformed countries has an even deeper implication. Leo Jud, a colleague of Zwingli and destroyer of icons, distinguished between artificial images of God made by human beings and the true image of God—that is, human beings—made by God himself. Portraits depict "living images made by God and not by the hands of men,"[10] a profound concept that underlies the work of perhaps the greatest Protestant painter, Rembrandt. In the faces of his subjects—children, merchants, ordinary families—one can discern their personalities and value as the image of God. The Reformation emphasis that each individual can have a direct, personal relationship to God, the teaching that family life is good and fully sanctioned by Scripture, that all vocations can be means of serving God—these teachings are eloquently proclaimed in the "secular" subject matter of Reformation art, which is thus really no less religious than the more explicit, otherworldly art of the Middle Ages.

The great nonrepresentational art form of the Renaissance was music. The Reformers from Luther to Zwingli reveled in music. "The Puritan's high esteem for music," observes Lawrence Sasek, "his usual exemption of it from the criticism and suspicions directed at the other arts, arose from its nonrepresentational nature. . . . Its appeal was purely aesthetic, and by accepting it, the Puri-

tans accepted art as form, unmixed with theological or moral elements."[11] Music, praised everywhere in Scripture, is the ultimate nonrepresentational art, aural rather than visual, sequential and historical rather than spatial. It deals with no "likenesses" whatsoever, yet it is art of the highest craftsmanship and aesthetic impact. The Reformation created an outpouring of music not only in hymns, music with the content of the Word, but also in instrumental music. The Reformation's legacy to music finds its culmination in the piety and artistry of perhaps the greatest Christian composer, Johann Sebastian Bach. His music, like the Middle Eastern tapestry and illuminated manuscripts, is both intricate and patterned, imaging incredible freedom and incredible order, pure aesthetic joy and adulation of the glory of God.

Post-Reformation

After the Reformation, even when it seemed Christianity was being displaced from its central authoritative position in Western culture, Christians continued to follow and to initiate artistic change. In literature, for example, Samuel Johnson did much to exemplify and establish the principles of neoclassicism, as did Samuel Coleridge for romanticism and T. S. Eliot for modernism. All three, representing different styles, periods and artistic movements, were confessing orthodox Christians. How is this possible? Simply because, again, religion and aesthetics are not the same thing.

Religion can inspire and give both energy and content to art, but it can be expressed through many different aesthetic forms. Artistic movements, which must be a function of the culture of the time and the inherent workings of the history of art, cannot be canonized. Johnson believed that art needed the discipline of reason, clarity and order; Coleridge stressed the role of the creative imagination in art; Eliot believed poetry should reflect and expose

the fragmentary tensions of life. Certainly, in their contexts, all of them were right. The neoclassical, the romantic and the modernist could all agree on the incarnation and atonement of the Christ who never changes, unlike art which is destined to pass away.

Art invariably reflects the temper of its culture. Certainly much Christian art has reflected the inadequacies of its times and the shallowness of certain artistic theories, pandering to the marketplace, trivializing or sentimentalizing important Christian concerns. These are aesthetic faults; more piety on the part of the artist cannot normally solve these problems. Ability, intelligence, knowledge and craftsmanship—the gifts of Bezalel—usually can. A nonidolatrous view of art liberates the artist to participate in and enjoy a wide range of artistic styles and contents, from the explicitly religious to the purely secular.

Psalm 102 speaks of the distinction that must be kept between the transitory quality of human life and the natural order, both of which are ruled by the principle of change, and the transcendent, changeless quality of God. The lines apply to art no less than to civilizations:

> *They will perish, but thou dost endure;*
> > *they will all wear out like a garment.*
> *Thou changest them like raiment, and they pass away;*
> > *but thou art the same, and thy years have no end.*
> *The children of thy servants shall dwell secure;*
> > *their posterity shall be established before thee. (Ps 102:26-28)*

Art belongs to the realm of the changeable—it must not be worshiped nor, I would say, treated with undue conservatism. But God does not change—theology may not be revised along with artistic fashions. God is continually at work in the midst of the changes, and his Word is continually relevant to every culture despite any "future shock" (Mt 24:35).

The psalm also speaks of the security that God's children will

have amid all these changes. Christian artists should not stake everything on an artistic movement, on the rise and fall of fashions, aesthetic manifestoes and waves of the future—all of which last only until the next theorist comes along. As Proverbs 18:17 suggests, "He who states his case first seems right, until the other comes and examines him." Rather, Christian artists should rely on God alone and after that, keeping in mind the "posterity" of Bezalel and the range and possibilities suggested in God's Word, express the gifts entrusted to them and do pretty much what they like.

6
The Brazen Serpent:
Art and Evangelism

ART BY CHRISTIANS DOES NOT HAVE TO BE EXPLICITLY "ABOUT" Christianity. Any artifact, whether it represents part of God's creation or is an abstract, new arrangement of sound, color or form, partakes of created existence and is thus under the lordship of Christ. This point must be emphasized. Art that is Christian does not have to be restricted to Bible story illustrations. Novels do not have to portray conversions. Songs need not by hymns. In fact, the closer art comes to being "religious," the more problematic it can become. Nevertheless, the reality and indeed the urgency of the Christian message impel some artists to communicate it to others, to express their faith through their art. This too is legitimate. Works of art described in the Scripture—the ark of the covenant, the brazen serpent—sometimes express precisely the saving action of God and communicate both God's law and the gospel.

Consider the brazen serpent. On the journey from Egypt to the

Promised Land, miraculously delivered, guided and sustained, the people rebelled against the life of freedom and faith:

> *From Mount Hor they set out by the way to the Red Sea, to go around the land of Edom; and the people became impatient on the way. And the people spoke against God and against Moses, "Why have you brought us up out of Egypt to die in the wilderness? For there is no food and no water, and we loathe this worthless food." Then the LORD sent fiery serpents among the people, and they bit the people, so that many people of Israel died. And the people came to Moses, and said, "We have sinned, for we have spoken against the LORD and against you; pray to the LORD, that he take away the serpents from us." So Moses prayed for the people. And the LORD said to Moses, "Make a fiery serpent, and set it on a pole; and every one who is bitten, when he sees it, shall live." So Moses made a bronze serpent, and set it on a pole; and if a serpent bit any man, he would look at the bronze serpent and live. (Num 21:4-9)*

The people were impatient with the life God was calling them to experience. They were not satisfied with the daily sustenance God was granting them. They were sick of manna, that miraculous bread of heaven: "We loathe this worthless food." They thought it was boring. God punished this monstrous ingratitude by a plague of poisonous snakes. Terrified by God's judgment, the people turned to Moses to intercede for them. God's response was to have Moses make a work of bronze through which the people could experience divine deliverance and healing. Why, though, does God choose to work in such a curious and roundabout manner? Why does he not just heal them if that is his purpose? Why is their healing connected with looking at a bronze replica of a snake, of all things?

Portraying Judgment and Redemption
Here Scripture gives us a profound example of how art can be used

to communicate both the law and the gospel, creating in the audience both conviction of sin and an intimation of salvation by grace through faith. What God wanted the people to feast their eyes on was an image of the very punishment he was inflicting on them. He wanted them to truly look at his judgment and the reality of their sinfulness. But did they not know this already? Could they not see this judgment all around them in the real snakes that were crawling through the camp? Why was looking at a representation, a work of shining bronze, more convicting than the snakes of flesh and blood and venom?

Scripture here suggests something about how art functions that modern theorists are just noticing. Art is powerful because it heightens perception. It does this partially by lifting an object or experience out of its normal context so that it can be apprehended freshly and more fully. Human faces are everywhere, but a portrait causes us to see a human face as a special object of contemplation. Part of the joy of reading good fiction comes from the sense of recognition as our own experiences are called forth and intensified by the work of art which, in a sense, reveals what we have always known. Art can take a common object or a universal experience and, by aesthetic techniques of form and distancing, disclose that object or that experience in a compelling way, adding meaning to the image.

When the Israelites were looking at the bronze serpent glittering in the desert sun, they were seeing it in a different way than they saw the vipers swarming through their tents. The brazen serpent had a meaning that enlightened them about the meaning of the real serpents all around them. They were gazing, in the image, at God's wrath against their sin. The real snakes were not simple vipers of the desert, a natural disaster, but instruments of God's anger, as the metallic statue by virtue of its divinely proclaimed *meaning* forced them to understand.

God wanted the people to look at this image of a snake, lifted up

out of the context of their suffering, to make them fully and deeply recognize both his wrath and their sin which provoked it. That is, he was using the artifact to bring his people to repentance. When they looked on the brazen serpent, when they recognized where they stood under God's judgment, they could be healed.

The brazen serpent had another meaning as well. "As Moses lifted up the serpent in the wilderness," says our Lord, "so must the Son of man be lifted up, that whoever believes in him may have eternal life" (Jn 3:14-15). Speaking of his imminent crucifixion, Christ says, "Now is the judgment of this world, now shall the ruler of this world be cast out; and I, when I am lifted up from the earth, will draw all men to myself" (Jn 12:31-32).

The brazen serpent symbolizes the lifting up of Christ on the cross, in whom the sins of the world and Satan himself, "that ancient serpent," are judged and annihilated (Rev 12:9). Christ on the cross, in the mystery of the atonement, actually *became* sin: "For our sake he made him to be sin who knew no sin, so that in him we might become the righteousness of God" (2 Cor 5:21). The sin and unbelief of the Israelites in Moses' day, along with the sins of the entire world, were nailed to the cross in the innocent body of our Lord, who then bore all the judgment and wrath that sin deserves. It was through this atonement that the repentant Israelites in the desert and all other sinners throughout time are really forgiven.

The brazen serpent brought healing because it represented sin in the depths of its meaning, as rejection of God's grace, as provoking God's wrath, as originating in Satan; at the same time it represented God's provision for sin, to be fully manifest in Jesus Christ. Looking to this image in the midst of judgment typifies what it means to look to Christ for salvation, and it is through this act of faith that God's people, poisoned in their inmost being and dying from the sting of the serpent, receive healing.

Law and Gospel

The brazen serpent communicates two aspects of God's message: the law, which makes us aware of our lostness, and the gospel, which reconciles us to God through Christ. The messages are different, but they are both essential to evangelism. Unless people are confronted with God's holiness and what he requires of us, they cannot be aware of their need for Christ. Instead they will either trust their own works, thinking them sufficient, or be completely uninterested in God; both exist in the deadness of spiritual complacency. "Through the law," says Paul, "comes knowledge of sin" (Rom 3:20). The proper response to the law is repentance, whereupon sinners, despairing and broken by the realization of their lostness, can cling to Christ, who offers free forgiveness and a new life in his Spirit. The proper response to the gospel is faith.

> For no human being will be justified in his sight by works of the law, since through the law comes knowledge of sin. But now the righteousness of God has been manifested apart from law, although the law and the prophets bear witness to it, the righteousness of God through faith in Jesus Christ for all who believe. For there is no distinction; since all have sinned and fall short of the glory of God, they are justified by his grace as a gift, through the redemption which is in Christ Jesus, whom God put forward as an expiation by his blood, to be received by faith. (Rom 3:20-25)[1]

The law and the gospel serve different functions. One condemns, the other liberates; one kills, the other gives life (2 Cor 3:6). But both, working together, are essential in evangelism.

In expressing God's message through art, the distinction between law and gospel is helpful to keep in mind. The brazen serpent and the ark of the covenant with its broken tablets and the blood on the mercy seat express fully both the law and the gospel. Many works of art outside of the Bible do likewise. The great crucifixes, the paintings of Christ's passion, the poetry of George Her-

bert, the fiction of Flannery O'Connor: these explicitly depict both the enormity of sin under the law and the greater vastness of grace under the gospel. Such works are evangelistic in the fullest sense.

The Universal Nature of the Law

The law not only reveals sin, but it also reveals God's righteousness. It functions not only to drive sinners to Christ but also to restrain evil and give believers a definite guideline for a God-pleasing, righteous life. In this sense, the moral law is a matter for joyful contemplation (Ps 19:7-11; 119:70-72). Unlike the gospel, the law is not exclusively the property of the Christian church. Fully and authoritatively revealed in Scripture, God's moral imperatives are also in the essence of human nature. "When Gentiles who have not the law do by nature what the law requires, they are a law to themselves, even though they do not have the law. They show that what the law requires is written on their hearts, while their conscience also bears witness and their conflicting thoughts accuse or perhaps excuse them on that day when, according to my gospel, God judges the secrets of men by Christ Jesus" (Rom 2:14-16). Those who do not know the Scriptures nevertheless know "by nature" what the law demands. The conscience, although it can be seared by continual sin, bears testimony to the moral dimension of life, and their conflicting thoughts are evidence of their need for God (Rom 1).

God's universal law has a social dimension as well. These principles of right and wrong make human community possible. Romans 13:1-7 describes secular authorities as agents of God's wrath, that is, of God's law. God's objective principles of justice are necessary if sinful human beings are to band together in societies. "Be subject for the Lord's sake to every human institution, whether it be to the emperor as supreme, or to governors as sent by him to punish those who do wrong and to praise those who do right"

(1 Pet 2:13-14). The pagan lunatic Nero (whom Peter would here be referring to), a tribal chieftain in New Guinea, the Communist Commissars of the Soviet Union and the Congress of the United States: all, insofar as they restrain anarchy, can be used as servants of God's law, even though because of evil they may fail to truly and fully administer God's justice.[2] By the same token moral teachers from every culture and religion, if they teach truly, are all promulgating the same law.

The church has always recognized this. It has honored the "virtuous pagans," such as Socrates, Aristotle and Virgil, as teaching valid moral principles even though they were blind to the gospel. God's revelation and moral authority are universally operative even in those who do not acknowledge him.[3]

This is the point at which even art by non-Christians can be related to God's message and, to a point, to the work of evangelism. Even the most secular art can speak to us of God's law and our lost condition. Again, the law cannot save; but when a work of art seriously and honestly explores the moral dimensions of life, as great art invariably does, it can be of immeasurable spiritual value. One can find in purely secular, ostensibly nonreligious art, the message of God's law.

Self-consuming Art

When we think of "moral" art, the didactic and moralistic come to mind. These works are designed solely to convey a message; their main purpose is to teach some moral or lesson in life. Such works are probably over maligned. *Aesop's Fables*, the novels of Dickens, Tolstoy's short stories, the photographs of Dorothea Lange are all frankly didactic and at the same time exhibit great artistic skill. There is a place for didactic art, art that teaches moral principles in a straightforward way, although particular examples are often aesthetically clumsy.

Such didactic work partakes of the law, but the "evangelical" or "theological" use of the law is very different. One function of the law is to establish social values, to show people how they must behave to live harmoniously with others—the province of most moralistic art. The theological use of the law, however, is to convict people of sin, to confront them with the enormity of their failure to be righteous of themselves and to drive them to Christ. Contemporary critic Stanley Fish distinguishes between art that is self-satisfying and art that is self-consuming. The former affirms the reader, telling its audience only what it wants to hear, confirming the reader's values and creating a sense of security and complacency. Most conventionally didactic literature is of this kind. But the greatest art, according to Fish, is self-consuming. Such work "consumes" the self; it tells readers what they do not want to hear, challenging their values and destroying their complacency.[4]

The theological use of the law is clearly self-consuming in this sense: "Our God is a consuming fire" (Heb 12:29). In fact, to use the law in a self-satisfying way can be dangerous, for it reinforces the illusion that we are able to be righteous of ourselves, that with enough effort we can save ourselves through our works. Such self-righteousness, such trusting in our own works, shuts out the work of Christ: "You who would be justified by the law; you have fallen away from grace" (Gal 5:4). Paradoxically, then, some of the most spiritually dangerous works of art may be those that seem most moral—the self-help tracts, the Horatio Alger-style books that teach rugged individualism, self-sufficiency, and that anything can be accomplished if one just works hard enough, the optimistic works that suggest that we really are not so bad, that virtue is easy. At any rate, the best works of art make no such facile assumptions. Instead, like the evangelical function of the law, they tend to consume the reader's moral complacency in a way that can quicken a dead conscience and perhaps, through the violence of leveling moun-

tains and filling valleys, prepare a way for the Lord (Is 40:3-4).

Works of art can convey this evangelical function of the law in many ways. Many critics have observed how tragedy presents a hero with infinite aspirations who is forced to realize his own finiteness. His pride leads only to catastrophe as he comes face to face with the limitations of mortality and the human condition. The audience feels pity for the hero and fear for themselves, an experience which leaves them emotionally drained, but cleansed. comedy likewise deals with human limitations. Here the limits are accepted and seen as normative, against which human pretensions are shown to be absurd and laughable.[5] Both the tragic and the comic modes of art—and this would hold true not only for literature but also for "tragic" paintings such as the *Guernica* and "comic" paintings such as those by Daumier—by their nature tend to be applications of the law.

Art and the Ugly Truth
A work may deal with the moral dimension either explicitly or implicitly. Many explore moral problems and dilemmas with searching urgency. They honestly put forward the facts of human responsibility and the claims moral principles make on us. Others follow out the implications of ethical decision and come to some moral impasse, showing that even our righteousness is problematic, that even when we do what we think is right, our actions are tainted by our moral contradictions.

Satire applies the law like a bludgeon. This genre, although it sometimes appears to be lowest on the scale of idealism, usually assumes the strictest standards of morality, against which the target of the satire is measured. The satirist exposes and ridicules hypocrisy and injustice, using laughter as a cutting offensive weapon. Laughter and derision are also connected with God's law and his wrath: "He who sits in the heavens laughs; the LORD has them in

derision. Then he will speak to them in his wrath, and terrify them in his fury" (Ps 2:4-5). That artists tend to be social critics, often caustic ones, is due, according to Herbert Schneidau, to the primal influence on Western culture of the Bible with its prophetic insistence that every human institution or value come under the judgment of God's transcending law.[6]

The negative also plays a role in art. So much of modern art—poetry, the novel, painting—projects a bleak view of the world and the human condition. Ugliness, emptiness and absurdity are nearly obsessions of contemporary artists, even Christian ones such as Flannery O'Connor. What do such depressing and pessimistic images have to say to Christians? Should not Christian artists resist this morbid concentration on the negative and project a more positive outlook on life?

Again the distinction between the law and the gospel helps us. Christians do have a hope and a joy that set them forever apart from the nihilists. Yet that hope and joy reside in Christ alone, not in worldly success, not in fallen human beings, certainly not in any kind of optimism that looks on only "the sunny side" of life. "The scripture consigned all things to sin," says Paul, "that what was promised to faith in Jesus Christ might be given to those who believe" (Gal 3:22). Contemporary Christians perhaps have neglected the radical implications of the doctrine of sin. Under the law "all things" are consigned to sin. Human beings are *depraved*; nature is under a *curse*. We need to understand this imaginatively to fully realize our condition and our need of Christ, in whom alone is salvation. Modern art and literature, far from contradicting Scripture on this point, actually confirm it. We are often so comfortable in our pleasures that we need to be forced to see the absurdities of our condition according to transcendent standards. And modern art can help us—even make us—do just that.

It has always seemed to me a great evidence for the Christian

faith that those who reject it acknowledge, if they are honest, that without God they have no hope in the world (Eph 2:12). Great artists generally do not pretend that the absence of God in their lives is in any way fulfilling or a cause of rejoicing. Lacking God, they express their own emptiness. Looking outward, they probe and find that everything—other people, their society, nature itself—is a sham and a cheat. Is not their experience exactly what the Christian would predict? Is not their cry of "meaningless-ness" a recognition of the same futility proclaimed in Scripture (Rom 8:20)? Do not all people who are complacent in their world-liness need to realize the message of Ecclesiastes, that "all things are full of weariness; a man cannot utter it; the eye is not satis-fied with seeing, nor the ear filled with hearing" (Eccles 1:8), and is this truth of the law not a necessary prelude to the good news of Jesus Christ?

In suggesting that secular art can speak to us of law and thus be part of the work of the gospel, some cautions are in order. Not all works of art speak of the law; some openly flout it, promoting immorality or moral relativism. These might be valuable aesthet-ically, but they can have no spiritual value and may well be idola-trous, as I suggested earlier. Some writers in their despair and negativism attack God along with everything else. Although Elijah provides a model for satire when he mocks the idolatrous priests (1 Kings 18:27), not all targets are fair game, even with Christian charity. Scripture forbids us to mock the messengers of God, the poor, our parents or God himself (2 Chron 36:16; Prov 17:5; 30:17; Gal 6:7). *Scripture* is the norm by which all moral teachings must be evaluated. Insofar as art by non-Christians agrees with God's universal law, as is often to be expected according to Romans 2:14-15, it can be of enormous spiritual benefit. It can uphold moral values and reprove moral failures. It cannot, however, communi-cate salvation.

The Scandal of Particularity

Although all people, to a certain extent, know the law, no one can know the gospel apart from the specific, revealed person of Jesus Christ. The gospel partakes of what has been called the "scandal of particularity." Salvation is contingent on faith in the transcendent but also historical Jesus Christ. "There is salvation in no one else, for there is no other name under heaven given among men by which we must be saved" (Acts 4:12). This particularity is sometimes embarrassing to Christians, but the specificity is essential to the gospel. The gospel is not a vague cosmic optimism, a utopian vision of everyone loving one another, or even a belief in a benevolent deity. It is rather the scandalous message of Christ crucified for sinners.

Scripture goes further, suggesting that this message is most scandalous to intellectuals, to those who prize eloquence and sophisticated kinds of knowledge.

Christ did not send me to baptize but to preach the gospel, and not with eloquent wisdom, lest the cross of Christ be emptied of its power.

For the word of the cross is folly to those who are perishing, but to us who are being saved it is the power of God. For it is written,

"I will destroy the wisdom of the wise,

and the cleverness of the clever I will thwart."

Where is the wise man? Where is the scribe [literally, the writer]? Where is the debater of this age? Has not God made foolish the wisdom of the world? For since, in the wisdom of God, the world did not know God through wisdom, it pleased God through the folly of what we preach to save those who believe. For Jews demand signs and Greeks seek wisdom, but we preach Christ crucified, a stumbling block to Jews and folly to Gentiles, but to those who are called, both Jews and Greeks, Christ the power of God and the wisdom of God. For the foolishness of God is wiser than men, and the weakness of God is stronger than men. (1 Cor 1:17-25)

Those of us in academia and the arts, who tend to see things in terms of "high culture" and sophisticated intellectualism, need to read 1 Corinthians over and over again. "The world did not know God through wisdom," nor through the law, nor through art, but only by "the word of the cross."

This we must remember not only in our relationship with God, but also in our relationships with other Christians. We tend to associate with others like ourselves and to despise others who do not share our aesthetic sensitivity and our intellectual preoccupations. It is easy for us, frankly, to be snobs—to set ourselves above the "bourgeois," the "vulgar masses," the common people of the world and of the church. The church is not based, however, on such intellectual, aesthetic or cultural standards:

> For consider your call, brethren; not many of you were wise according to worldly standards, not many were powerful, not many were of noble birth; but God chose what is foolish in the world to shame the wise, God chose what is weak in the world to shame the strong, God chose what is low and despised in the world, even things that are not, to bring to nothing things that are, so that no human being might boast in the presence of God. He is the source of your life in Christ Jesus, whom God made our wisdom, our righteousness and sanctification and redemption; therefore, as it is written, "Let him who boasts, boast of the Lord." (1 Cor 1:26-31)

This is not to say that there are no Christians who are wise according to worldly standards. There are simply "not many." Likewise, artists and academics who are Christians are likely to be a minority, both in their fields and in the church. We would love for Christianity to dominate modern philosophy and to take hold of the art world, but it is not likely. We would love for the church to attract more artists and intellectuals, for its members to be more open to the aesthetic dimension of life and sensitive to issues of the mind. Perhaps we are embarrassed by our local church, by the unedu-

cated Sunday-school teacher, by the usher in his polyester suit who makes visitors wear a name tag with a happy face, by the plastic flowers on the altar, by the minister with his homely examples and country mannerisms. It might be worthwhile to try to correct some of this, but if such things seem overly scandalous, it is we who are being "the weaker brethren" (Rom 14).

The strength of the church universal is its diversity (1 Cor 12). People of all classes, races, ages, interests and talents are gathered together in Christ's body. This is evident in the local church also (or it should be), as the rich, the poor, the cultured, the illiterate all come together in worship of the transcendent, immanent God. An artist or a scholar is no better than a car salesman, a "redneck" field hand, a "bourgeois" business executive or a semiliterate old woman before the altar of God. In fact, the "wise of this world" are probably at a disadvantage and are in particular need of their church community to ground them in the full, common texture of humanity and to keep them humble and chastened. Such diverse fellowship is important not only to artists spiritually, but also for their art. It protects them from elitism and keeps them sympathetic to ordinary experiences and to the trials of living; it keeps them human.

Godly Wisdom
After minimizing worldly wisdom, the apostle Paul goes on to stress that there is, however, wisdom in the context of the true faith. "Yet among the mature we do impart wisdom, although it is not a wisdom c f this age or of the rulers of this age, who are doomed to pass away. But we impart a secret and hidden wisdom of God, which God decreed before the ages for our glorification" (1 Cor 2:6-7). Such wisdom is for the mature and is discerned spiritually. Unlike earthly philosophies and artistic fashions which pass away as they are continually succeeding each other (compare Prov 18:17), this wisdom does not change. It comes not from human ingenuity

but divine revelation. It can be conveyed through human instruments, but its effectiveness depends not on the eloquence with which it is expressed but on the Holy Spirit.

Art can, however, convey the gospel, the word of the cross, as we see in biblical art—the bloody ark of the covenant, the brazen serpent—and in the whole corpus of Christian art. This message, however, is highly specific, unlike the law which is broad and universal in its scope. "Not many" artists, relatively speaking, will respond to the gospel, let alone proclaim it in their art. Nor is the evangelistic impact of a gospel-bearing work contingent on the skill or eloquence of the artist. It is God who acts in the gospel, calling people to himself, and he is not thwarted by human limitations. He can speak through inferior art—a cheap tract, a clumsily executed crucifix—as well as through an aesthetic masterpiece.

Having said this, and remembering that art need not be evangelistic or have any propositional content at all to please God, we may consider *how* art can convey the gospel. First, it needs to maintain the "scandal of particularity." That is, it must present directly or indirectly the person and the name of Jesus Christ. An evangelistic work cannot present the gospel by vague intimations or moralizing. It must point explicitly or symbolically, but always clearly, to Jesus of Nazareth and his work. This does in a sense limit the artist who desires to be an evangelist, but this is the same limitation given to any other preacher or witness and, considered rightly, it is scarcely a limitation. It is the most profound and inexhaustible of subjects. What can send the imagination reeling like the doctrine of the Incarnation, the infinite concealed in the finite, or the atonement, the tragedy of sacrifice and the comedy of resurrection and forgiveness of sins? All of human nature and the divine nature are present in Christ, who experienced and suffered the whole range of human experience, including the entire weight of the world's sin. As George Herbert observes in his poem "The Agonie,"

Philosophers have measur'd mountains,
Fathom'd the depths of seas, of states, and kings,
Walk'd with a staffe to heav'n, and traced fountains:
 But there are two vast, spacious things,
The which to measure it doth more behoove:
Yet few there are that sound them; Sinne and Love.

Who would know Sinne, let him repair
Unto mount Olivet; there shall he see
A man so wrung with pains, that all his hair,
 His skinne, his garments bloudie be.
Sinne is that presse and vice, which forceth pain
To hunt his cruell food through ev'ry vein.

Who knows not Love, let him assay
And taste that juice, which on the crosse a pike
Did set again abroach; then let him say
 If ever he did taste the like.
Love is that liquour sweet and most divine,
Which my God feels as bloud; but I, as wine.[7]

"Few there be that sound them," but the depths of human sin and
the even greater depths of divine love, both of which are resolved
in Christ, are "vast spacious things" that can engage the fullest
powers of the greatest artists.

This is not to say that evangelistic art must always be *about* the
historical Christ, that one must simply retell or depict Bible stories
in all of one's art. This, however, must not be despised. Certainly,
in the visual arts, painters and sculptors turn again and again to
biblical narratives as subjects for their art. The nativity, the adora-
tion of the Magi, the Virgin Mary with the Christ child, the cruci-
fixion, the burial, the resurrection—such set pieces of Christian
art exalt the Christ of the Scriptures in a very explicit and powerful

way. Such traditional subjects deserve to be continued by contemporary Christian artists. One may also present Christ in other contexts, showing the ascended Christ as he relates to all of life and to individual needs.

Gospel-bearing Art

Some examples from literature may suggest how a work of art can be gospel bearing in this sense. In "Gerontion," T. S. Eliot presents images of the bleakness and sterility of modern life, in which, "In the juvescence of the year/ Came Christ the tiger" (ll. 19-20). Eliot suggests, concretely, the impasse of the law, our intrinsic failure to satisfy its demands, and the overwhelming, violent action of Christ in taking us by grace into himself:

Neither fear nor courage saves us. Unnatural vices
Are fathered by our heroism. Virtues
Are forced upon us by our impudent crimes.
These tears are shaken from the wrath-bearing tree.
The tiger springs in the new year. Us he devours. (ll. 45-49)[8]

Flannery O'Connor, in "The Displaced Person," likewise plays Christ against modern points of view in her story of a family of refugees that upsets the balance of a complacent southern farm:

The priest let his eyes wander toward the birds [peacocks]. They had reached the middle of the lawn. The cock stopped suddenly and curving his neck backwards, he raised his tail and spread it with a shimmering timbrous noise. Tiers of small pregnant suns floated in a green-gold haze over his head. The priest stood transfixed, his jaw slack. Mrs. McIntyre wondered where she had ever seen such an idiotic old man. "Christ will come like that!" he said in a loud gay voice and wiped his hand over his mouth and stood there, gaping.

Mrs. McIntyre's face assumed a set puritanical expression and she reddened. Christ in the conversation embarrassed her

the way sex had her mother. "It is not my responsibility that Mr. Guizac has nowhere to go," she said. "I don't find myself responsible for all the extra people in the world."

The old man didn't seem to hear her. His attention was fixed on the cock who was taking minute steps backwards, his head against the spread tail. "The transfiguration," he murmured.

She had no idea what he was talking about. "Mr. Guizac didn't have to come here in the first place," she said, giving him a hard look.

The cock lowered his tail and began to pick grass.

"He didn't have to come in the first place," she repeated, emphasizing each word.

The old man smiled absently. "He came to redeem us," he said and blandly reached for her hand and shook it and said he must go.[9]

This passage shows another way that art can deal with the gospel. In this conversation with an absent-minded or perhaps single-minded priest, O'Connor associates Christ with the glory of the peacock and with the refugee Mr. Guizac. In the course of the story, Mrs. McIntyre's reactions to the peacocks and to the refugees parallel her embarrassment with Christ. Her complicity in the refugee's death helps us understand in what sense we are responsible for Christ's death; and her final breakdown (as a result of her guilt) forces her finally to listen, without being able to interrupt, to what the priest has been trying to tell her. As with the ark of the covenant and the brazen serpent, the facts of the gospel are presented *symbolically*.

In art, symbols are usually necessary to penetrate beneath a surface appearance, to explore and present *meanings*. A painting of Christ may appear to some people as the painting of any other man. A painting such as Van Eyck's *Adoration of the Lamb* which depicts Christ through the symbol of a lamb pouring out its blood into a

chalice, a lamb slain yet alive, explores and communicates the meaning, not just the appearance of the Christ. Religious art nearly always resorts to symbolism, which simply means expressing transsensory ideas through concrete images. Paintings of the Christ child generally show him playing with a goldfinch, the bird that eats thorns, expressing through the symbol that this is not simply another cute little baby, but that this child will reverse the curse of Adam and rise from the dead, turning his crown of thorns into a matter of joy (Gen 3:18). Such symbols abound in the most narrative biblical paintings: the trampled serpent, the skull, the crown, the halo, the beaten gold.

The "Christ figure" in literature has fallen into some disrepute. It seems that some critics can find a symbol for Christ in anything, just as Freudian critics can find sexuality hidden in the most chaste of expressions. Many people, however, are unaware of how symbols, such as those for Christ, actually do function. To say Mr. Guizac in O'Connor's story is a Christ figure is not to say that he *is* Christ. Rather, what happens to Mr. Guizac—the thanks he gets for doing everyone's work for them and for being so perfect—can illuminate for the reader, imaginatively, an aspect of what happened to Christ and how we respond to him. Joe Christmas in William Faulkner's *Light in August* is another obvious Christ figure, not in his essence as a character but in the symbolic way the author makes him a sacrificial victim. Such Christ figures—the outcast who dies for the community, the god that dies and rises to life —are, in fact, everywhere in literature and in myth, both among Christians and non-Christians. As such they are testimonies to the universality of the Christian mystery so deeply rooted in the needs of the human imagination. Having actually been fulfilled in the historical Jesus, they constitute images and yearnings which the Scriptures proclaim as fact.

Moreover, the Bible says that it is Christ who is the living Word

that underlies all of existence:

> *He is the image of the invisible God, the first-born of all creation;*
> *for in him all things were created, in heaven and on earth, visible and*
> *invisible, whether thrones or dominions or principalities or authori-*
> *ties—all things were created through him and for him. He is before all*
> *things, and in him all things hold together. He is the head of the body,*
> *the church; he is the beginning, the first-born from the dead, that in*
> *everything he might be pre-eminent. For in him all the fulness of God*
> *was pleased to dwell, and through him to reconcile to himself all*
> *things, whether on earth or in heaven, making peace by the blood of*
> *his cross. (Col 1:15-20)*

Thus Christ underlies *everything*, from the created universe (the
"visible") to the abstract world of spiritual ideas (the "invisible");
in him is everything that is fully human and everything that is fully
divine. Indeed, "in him all things hold together."

Thus Christ is at the center. He is the *logos*, the explanation, the
origin and the purpose, of every entity. This means that, to one
who knows Christ, anything can be seen in light of Christ. When
Gerard Manley Hopkins writes of a hawk in "The Windhover,"
he sees in that hawk the qualities of "Christ our Lord." The most
common, ordinary actions can be made to speak to us of spiritual
realities, of Christ, the *logos* himself, as G. K. Chesterton, George
MacDonald and many other artists continually reveal.

The simple act of eating, for example, images in the most pro-
found way the basic, unquestionable truth that there can be no life
apart from sacrifice. Every life depends on the sacrificial death of
some other living thing. The gentlest of animals depends upon the
tearing and eating of living plants, whose life is given to nourish
the other life. When we eat meat, we are nourished through the
death of another creature. The sacrificial nature of eating meat is
fully recognized in the Old Testament dietary regulations. If we
spurn such sacrifices, whether of animals or of plants, we starve to

death. In a fallen world, this is a matter of violence but also of joy, as life literally is transformed into other life; the magical fish in George MacDonald's "The Magic Key" take joy in being chosen to be eaten. The point is, the seemingly arcane and primitive idea of sacrifice—that life is made possible by the death of another living being—is a fact re-enacted every time we sit down to a meal. Behind it all is the person of Christ, who made himself the sacrifice, dying so that we might live, expressing what he has done for us through the sacrament of bread and wine.

> *The Lord Jesus on the night when he was betrayed took bread, and when he had given thanks, he broke it, and said, "This is my body which is for you. Do this in remembrance of me." In the same way also the cup, after supper, saying, "This cup is the new covenant in my blood. Do this, as often as you drink it, in remembrance of me." For as often as you eat this bread and drink the cup, you proclaim the Lord's death until he comes. (1 Cor 11:23-26)*

Another powerful gospel-bearing image set forth in the Bible and occurring everywhere in the arts is that of water. It cleanses, brings life to parched ground and thus expresses the mystery of death and rebirth. Christian baptism employs simple water to convey the gospel of Christ. The wealth of sacramental imagery throughout Christian art—indeed, the sacramental imagination, which tends to see the works of grace in the most ordinary physical objects and events—is particularly important in depicting Christ and his work.

The Pre-eminence of the Word

The Scriptures make another important point about how the gospel is conveyed:

> *How are men to call upon him in whom they have not believed? And how are they to believe in him of whom they have never heard? And how are they to hear without a preacher? And how can men preach unless they are sent? As it is written, "How beautiful are the feet of*

those who preach good news!" But they have not all obeyed the gos-
pel; for Isaiah says, "Lord, who has believed what he has heard from
us?" So faith comes from what is heard, and what is heard comes by
the preaching of Christ. (Rom 10:14-17)

Technically, it is the *Word* of God which conveys the gospel. Faith
comes from *hearing*, from responding to a message discerned
through language. A person may confront Christ by reading the
Scriptures, through hearing God's Word preached in a sermon or
witnessed to in a personal conversation or a gospel tract. Hearing,
rather than seeing or feeling, is the main way we relate to God, and
it is God's *Word* that is the normal means of grace. (The sacraments
are often described as *visible words*, presenting the gospel in tan-
gible form so that Christ's promises can be literally tasted and ex-
perienced as well as verbally apprehended, but even here the ele-
ments must always be accompanied by the *words* of consecration.)

This priority of the Word means that, for art to convey the gospel,
it must be in some sense propositional. It must be connected, di-
rectly or indirectly, to language. Pure art need have no particular
content at all to be pleasing to God, as has been discussed earlier.
Its main purpose is to embody aesthetic forms. To give or receive
the highest aesthetic pleasure is a worthy and exalting goal, al-
though aesthetic delight as such cannot lead anyone to Christ. The
preaching of Christ involves propositional statements about the
person and work of Christ. Art can convey such statements either
directly through the verbal medium of literature or indirectly
through artistic symbolism. But "the word," that is, a specific and
paraphrasable content, is necessary for evangelism.

Zwingli makes an important point on the priority of "the word"
in religious art, as summarized by Charles Garside:

To begin with, men can learn nothing of the content of God's
Word from an image. "Why," Zwingli rhetorically asks, "do we
not send images to unbelievers so that they can learn belief from

them?" Precisely because we would be required to explain what they mean, which in turn requires knowledge of the Word. "If now you show an unbelieving or unlettered child images, then you must teach him with the Word in addition, or he will have looked at the picture in vain." For if "you were newly come from the unbeliever and knew nothing of Christ and saw Him painted with the apostles at the Last Supper, or on the Cross, then you would learn nothing from this same picture other than to say 'He who is pictured there was a good-looking man in spite of it all.' "... One may have images of Christ, but they are powerless; the "story must be learned only from the Word, and from the painting one learns nothing except the form of the body, the movements or the constitution of the body or face."[11] Zwingli, as Garside shows, was not opposed to art per se, simply to the medieval church's dependence on icons and neglect of the Word of God.

This does not mean, though, that the visual arts cannot convey the propositions of the gospel. The classical definition of a sacrament can be helpful here—that is, the physical elements become sacramental when they are connected to the Word of God. A work of art, by analogy, may be "connected" to the Word and thus communicate the meaning powerfully, not simply as an abstract doctrine but as a living and concrete reality.

It is probably true that a mere picture of the crucifixion would be no substitute for missionaries who could explain what the crucifixion means. Alongside the explanation, though, the painting might well help the people to realize and to imagine the extent of Christ's suffering for them. To someone who knows nothing of the New Testament, a painting of Christ by Rembrandt may be simply another figure of a bearded man in a robe, splendidly executed in terms of color and balance. But to someone who *knows*, however faintly, that this represents the Son of God, who has

had some exposure to the Word, such a painting may reawaken a sense of the love of God.

Recovering Meaning

It is easy to become complacent with things that are familiar to us. We may take concepts such as grace, sacrifice, incarnation, salvation and so on for granted, so that we no longer "hear" them. A work of art can help us realize these concepts in a fresh way, revitalizing their meaning for us. A great painting of the crucifixion can help us imagine what Christ suffered for us, reminding us of what we knew abstractly but did not always fully appreciate. Art and its techniques such as symbolism can help *recover* meaning that has been forgotten or that is so familiar that it tends to be ignored.

Just as a picture can illuminate a word, a word can illuminate a visual image and charge it with meaning. The title of a work of art, for example, can be very important. The Scriptures describe two monoliths, huge bronze pillars decorated with nets and pomegranates, which were to adorn the Temple complex (1 Kings 7:15-22). They were imposing aesthetic objects, but their specific *meaning* was conveyed by their names: Jachin ("God establishes") and Boaz ("He comes with power"). The pillars thus presented and imaged artistically God's establishing power. The connection between the meaning and the aesthetic form is perfect, but without "the word" the pillars would never communicate such a meaning. Similarly, an abstract painting that consists of a rich, black canvas bisected by a vibrant yellow horizontal line may be aesthetically interesting. If that painting were entitled "The Creation," however, a meaning emerges, and the painting could express and help the viewer imagine the radical nature of God's creative work described in Genesis 1: "And God said, 'Let there be light'; and there was light."

Modern aesthetic theory tends sometimes to minimize the im-

portance of language, so that works of art are numbered or only given descriptive titles. This is legitimate when the artist seeks to create a work that is purely aesthetic and nonreferential. Words, however, are still extremely important. People need to talk about art, to read and write about art. We can take pleasure from seeing paintings in a gallery, but reading the catalog of the collection, listening to a lecture by an art historian or reading a review by an art critic tends to increase the impact of any work of art.

This is the importance of literary or aesthetic criticism. Such explanations and scholarship literally connect the work of art to "words," to meanings, contexts, patterns, *logoi*. Criticism can cause the various meanings of a work to unfold so that they can be noticed more fully. Christian criticism can thus also be a gospel-bearing activity, as the Word of God is connected to the work of art. The depths of a work's symbols, the patterns of death and rebirth, the figures of substitution and exchange—these often need to be explained before they can be fully perceived in a work of art. Read Dante and then read Dante again in light of Charles Williams's *The Figure of Beatrice*.[12] A fascinating medieval *tour de force* can then be re-experienced as an overwhelming exposition of the love of God. Writing about art, or talking about art in an informal conversation after a movie or a play, can often occasion an explicit discussion of what the gospel says and what it means.

Because the gospel is a function of the Word as expressed in Scripture and in Jesus Christ, it is objective. This means, interestingly, that an artist does not necessarily have to be a Christian to be working with images that express gospel. Ezra Pound was not a Christian, but his "Ballad of the Goodly Fere" expresses with great orthodoxy the concept of the bodily incarnation and resurrection of Jesus Christ. The Jewish painter Marc Chagall has a painting, "The White Crucifixion," which powerfully depicts Christ's solidarity with the persecuted of modern times, with their sufferings

which he shared on the cross.

Any time artists deal honestly with sin, suffering, sacrifice, love and forgiveness, they may find themselves following the pattern that is engraved on the foundations of the world, the drama of redemption fulfilled by Jesus of Nazareth and revealed in the Scriptures. Gospel-bearing art need not necessarily be by Christian artists. But it usually is, since the gospel message, though universal in scope, is highly specific. "Few there be," says Herbert, that sound the depths of human sin and divine love as revealed in Christ. Not many of you, says St. Paul, were acclaimed by the standards of the world—which would probably include artistic canons. Yet those few whom Christ calls to this work God can use in a powerful way for the service of his Word.

Beauty That Compels Response
The Scriptures name aesthetic categories in connection with the impulse to proclaim God's salvation to the nations:

Sing to the LORD, bless his name;
 tell of his salvation from day to day.
Declare his glory among the nations,
 his marvelous works among all the peoples!
For great is the LORD, and greatly to be praised;
 he is to be feared above all gods.
For all the gods of the peoples are idols;
 but the LORD made the heavens.
Honor and majesty are before him;
 strength and beauty are in his sanctuary. (Ps 96:2-6)

The lover of God, in whose sanctuary is all beauty, can scarcely refrain from "telling of his salvation." The psalmist gives two reasons: first, the Lord is great in himself, intrinsically deserving all praise and exaltation; and second, because "all of the gods of the peoples" are false, so that the nations are in desperate need of

him. The psalmist exhorts us to declare God's glory and his saving works by writing a song about them, by composing music, a "pure" aesthetic form, and by putting words, God's words, to that music. This is our model for authentic gospel-bearing art.

In a discussion of the Christian implications of a popular movie, someone once asked me if anyone had actually come to Christ through all this symbolism and "hidden meaning." That, of course, is a good question. If art can convey the gospel, has anyone come to faith through art? Such a question is difficult to answer. Although all proclamations of the gospel depend on the sovereign Spirit of God for their efficacy in a person's heart, some people have indeed come to faith through the medium of art. I have had a student tell me that in her reading of Graham Greene's *The Power and the Glory* she came to realize what it means that Christ bears our sins. The novel helped her believe. Another person I know never really knew what the gospel was until she found it in the poetry of John Donne and George Herbert. C. S. Lewis's spiritual autobiography *Surprised by Joy* is largely a record of the books he was reading and the music he was listening to, the growth of his imagination, which in his case served to "prepare the way of the Lord." I know of others who have, in turn, come to faith through the works of C. S. Lewis—not only through his apologetic works but also through his fiction, through his characters such as Screwtape and his symbols such as Aslan.

The examples I know best come from literature, but I have heard of people who have had to consider the claims of Christ because they were overwhelmed by the cathedrals and museums of western Europe which testify so strongly, by aesthetic means, to the power of the Christian faith. This is not to say that the gospel is dependent on the skill of the artist or the aesthetic greatness of a work. People have been converted to faith in Christ through gospel comic books and apocalyptic novels about a worldwide dictator who takes

over and tattoos "666" on everybody's forehead. These are not masterpieces of literature. Nevertheless, if the objective gospel is there, God has promised that his Word "shall not return to me empty, but it shall accomplish that which I purpose" (Is 55:11).

The evangelist's job is to scatter the gospel like seeds in a field, leaving its effect and its increase to the Spirit of God. The gospel does not depend on human eloquence, but God can and does use art to proclaim his law and his gospel.

7
Mere Art

THE BRAZEN SERPENT WAS A GREAT EVANGELISTIC WORK OF ART. IT communicated God's law and gospel, symbolizing Christ on the cross and bringing healing to thousands. As one might expect, it was kept and treasured. Eventually, however, this historical instrument of God's grace was turned into an idol.

In the third year of Hoshea son of Elah, king of Israel, Hezekiah the son of Ahaz, king of Judah, began to reign. He was twenty-five years old when he began to reign, and he reigned twenty-nine years in Jerusalem. His mother's name was Abi the daughter of Zechariah. And he did what was right in the eyes of the LORD, according to all that David his father had done. He removed the high places, and broke the pillars, and cut down the Asherah. And he broke in pieces the bronze serpent that Moses had made, for until those days the people of Israel had burned incense to it; it was called Nehushtan. (2 Kings 18:1-4)

The bronze serpent, the work of Moses, had become another idol—just like the sacred pillars and the images of the fertility goddess Asherah. How could this happen?

From Treasure to Idol

For one thing, the serpent was probably interpreted according to the prevailing intellectual climate. Baalism also used images of serpents. The meaning of the brazen figure had changed for the Israelites. It had become a symbol for a syncretistic approach to religion. The Israelites might have reasoned as follows: "This is what Moses made. See how similar it is to the Baal serpents? All religions of the world are really one—the outward forms are different, but their essential content is the same. We ought not to be narrow-minded and intolerant. We should employ any means to reach the divine according to our own preferences."

Notice that we have heard this all before. Syncretism, the urge to combine religions, to select "the parts we like" from a smorgasbord of incompatible world views, has always been a threat to biblical faith. The brazen serpent would be especially insidious since it was made by Moses, a fact which could persuade a wavering Israelite to participate in such idolatry on the assumption that it was sanctioned by the messenger of God.

Chesterton has observed that the view that religions differ in their outward forms but that their essential content is the same is precisely backward. The forms of religions often *are* the same—patterns of worship and sacrifice, shared symbols such as serpents and blood. The difference is the content, what these forms *mean*.

Scripture affirms that Hezekiah was right to destroy the brazen serpent. The principle is important: no matter how successful a practice has been in the past, no matter how God has used a particular method or technique, it is possible to turn it into an idol, to pursue it for its own sake until it becomes an obstacle to true faith.

At that point, the practice, no matter how venerable, must be changed. Hezekiah's action is especially important for a biblical view of art. Art *is* sanctioned by God; it can even communicate in a powerful way God's law and his gospel. Yet we must not "burn incense to it."

Art should not be turned into an object of worship. The Israelites in the desert received the Word of God from the brass image; the movement was from God through the image to the viewers. The later Israelites reversed these spiritual vectors. They were not receiving anything from the image in the passive, receptive righteousness of faith. Rather, they were giving their prayers, offerings and allegiance *to* the image. They were not receptive to the intended meaning; they projected their own meanings onto the image, making it their focus. They were worshiping and praying to the creature rather than the Creator (Rom 1:25). They were also committing an aesthetic sin: they were *using* the art instead of *receiving* it.[1]

It is possible then to turn even the most theologically correct work of art into an idol. I have known Shakespearean critics whose religion is Shakespeare. They are so wrapped up in the aesthetic experience of the great plays that their lives are focused on them. Although Shakespeare always points outside himself to the world he is exploring, many scholars never notice that, so interested are they in his poetic genius. Aberrant critical approaches they treat as heresies, exhibiting all the intolerance and self-righteous zeal that they are so opposed to in the history of the church. I have known of others who dedicate themselves exclusively to "the theatre," who sacrifice everything—their marriages, their morals, their time—to the one goal of being an actor. Examples can be multiplied and multiplied for all of the arts.

This kind of idolatry is what C. S. Lewis explores in *The Great Divorce*. In the story, souls from hell are allowed to come to heaven, but they refuse to stay. Among them is an artist who cannot enjoy

the beauties of heaven because he is so intent on painting them.
A blessed spirit, on earth a fellow artist, tries to explain to him
that "if you are interested in the country only for the sake of paint-
ing it, you'll never learn to see the country."

> Every poet and musician and artist, but for Grace, is drawn
> away from love of the thing he tells, to love of the telling till,
> down in Deep Hell, they cannot be interested in God at all but
> only in what they say about Him. For it doesn't stop at being
> interested in paint, you know. They sink lower—become inter-
> ested in their own personalities and then in nothing but their
> own reputations.[2]

The artist learns that in heaven he will drink out of the river Lethe
and will forget all proprietorship in his works so that he will be
free to enjoy them without pride or modesty. All reputations, he is
told, are the same in heaven. When the artist learns, though, that
his works are now out of fashion on earth, he storms back to hell
to write a manifesto.

Demystifying Art

There is another sense in which we can "burn incense" to a work
of art: we can overmystify it, ascribing to it supernatural or re-
ligious functions. The passage on the destruction of the serpent
image says that "it was called Nehushtan." The Hebrew is rather
ambiguous here, but the King James Version translates the passage
"and he [that is, Hezekiah] called it Nehushtan," which means a
piece of brass. Hezekiah's reform was that he broke the image and
called it a piece of brass. One way to defeat idolatry is to demys-
tify the idol. This is what the prophets do, showing how the image
is made as a way to persuade the people that there is nothing super-
natural about it.

> *All who make idols are nothing, and the things they delight in do not
> profit; their witnesses neither see nor know, that they may be put to*

*shame. Who fashions a god or casts an image, that is profitable for
nothing? Behold, all his fellows shall be put to shame, and the crafts-
men are but men; let them all assemble, let them stand forth, they
shall be terrified, they shall be put to shame together.*

*The ironsmith fashions it and works it over the coals; he shapes it
with hammers, and forges it with his strong arm; he becomes hungry
and his strength fails, he drinks no water and is faint. The carpenter
stretches a line, he marks it out with a pencil; he fashions it with
planes, and marks it with a compass; he shapes it into the figure of a
man, with the beauty of a man, to dwell in a house. He cuts down
cedars; or he chooses a holm tree or an oak and lets it grow strong
among the trees of the forest; he plants a cedar and the rain nourishes
it. Then it becomes fuel for a man; he takes a part of it and warms
himself, he kindles a fire and bakes bread; also he makes a god and
worships it, he makes it a graven image and falls down before it.
Half of it he burns in the fire; over the half he eats flesh, he roasts
meat and is satisfied; also he warms himself and says, "Hah, I am
warm, I have seen the fire!" And the rest of it he makes into a god,
his idol; and falls down to it and worships it; he prays to it and says,
"Deliver me, for thou art my god!" (Is 44:9-17)*

By understanding the *technique* of artistry (notice the characteristic
fascination of the Hebrews for how things are built rather than their
physical appearance), by understanding the raw materials and the
process of creation, one is less likely to worship the work of art or
the artist. Consider Shelley's exalted view of the poet:

Poets . . . are not only the authors of language and of music, of
the dance and architecture and statuary and painting; they are the
institutors of laws, and the founders of civil society and the in-
ventors of the laws of life and the teachers, who draw into a cer-
tain propinquity with the beautiful and the true that partial
apprehension of the agencies of the invisible world which is
called religion.[3]

Against this view Isaiah reminds us that "the craftsmen are but men."

At one time in my life I was unusually taken with the poetry of Walt Whitman. He seemed to me inspired, a prophetic bard whose insights revealed the spiritual dimensions of ordinary life. Not only did I admire his poetry, but I took him as an oracle, an authority. Some time later I was engaged by a professor to help edit Walt Whitman's notebooks. In the course of this project I began to see Whitman in a different way. I could see how my favorite poems were actually written—the crossovers, the false starts, the constant revisions, the *labor* that went into them. I began to see the poet as a real person, his insecurities, his self-doubts, his ordinary family and business concerns, even his efforts to *create* an image of himself for his public. Whitman was demystified for me. And yet, and this is the important point, this knowledge of the real Whitman and the real processes of his art caused me to appreciate his poetry even more. I could see its artistry, its createdness. I no longer view "The Song of Myself" as an authoritative oracle of the transcendental ego, but as a *human* product, something *made* by a person, a work of art. It is not religion but poetry.

This distinction needs to be emphasized as it is important not only in avoiding idolatry but also in truly appreciating art. Matthew Arnold's view of poetry is representative of the way many people see art:

We should conceive of poetry worthily, and more highly than it has been the custom to conceive of it. We should conceive of it as capable of higher uses, and called to higher destinies, than those which in general men have assigned it hitherto. More and more mankind will discover that we have to turn to poetry to interpret life for us, to console us, to sustain us. Without poetry, our science will appear incomplete; and most of what now passes with us for religion and philosophy will be replaced by poetry.[4]

Against this view, in which poetry actually replaces religion, are the words of the Lord to Jeremiah.

> *"A tree from the forest is cut down, and worked with an axe by the hands of a craftsman. Men deck it with silver and gold; they fasten it with hammer and nails so that it cannot move. Their idols are like scarecrows in a cucumber field, and they cannot speak; they have to be carried, for they cannot walk. Be not afraid of them, for they cannot do evil, neither is it in them to do good."* ... *Beaten silver is brought from Tarshish, and gold from Uphaz. They are the work of the craftsman and of the hands of the goldsmith; their clothing is violet and purple; they are all the work of skilled men. But the* LORD *is the true God; he is the living God and the everlasting King. . . . "The gods who did not make the heavens and the earth shall perish from the earth and from under the heavens."* (Jer 10:3-5, 9-11)

One would think that Matthew Arnold's high view of poetry would make him more receptive to aesthetic experience, and that Jeremiah by contrast would be "anti-art." Actually, however, when art is forced to fulfill the function of religion, it no longer can be enjoyed simply as art.

How Serious Is Art?

Matthew Arnold is a great critic and poet, but his program forces him to apply extra-aesthetic standards to art. "The substance and matter of the best poetry," he writes, "acquire their special character from possessing in an eminent degree, truth and seriousness."[5] Imaginative literature now must be true; and the more true it is, the greater the work of art. The problem of insisting that a work of art be true, however equivocally "true" is defined, should be obvious. It works against fictionality and the very concept of artistic creativity. The real difficulty with Arnold's position is his insistence on seriousness. This would rule out Chaucer, for example:

However we may account for its absence, something is wanting, then, to the poetry of Chaucer, which poetry must have before it can be placed in the glorious class of the best. And there is no doubt what that something is. . . . The substance of Chaucer's poetry, his view of things and his criticism of life, has largeness, freedom, shrewdness, benignity; but it has not this high seriousness.[6]

Chaucer is like the stone that breaks the hammer. Any theory that would minimize Geoffrey Chaucer cannot be valid. Here the writer's "view of things and his criticism of life" are evaluated to determine artistic greatness. Chaucer fails Arnold's test, though, because he is not serious enough.

Views like Arnold's tend to prefer the tragic over the comic. They take art so seriously that they actually eliminate pleasure as an aesthetic category. Jeremiah, on the other hand, sees even the idols that lead the people into apostasy as in themselves morally neutral: "Be not afraid of them, for they cannot do evil, neither is it in them to do good." They are not alive. Such powers apply only to people. One should not be in awe of works of art. They are the creations of artisans, whose work Jeremiah describes in detail. Isaiah even sounds a note of aesthetic appreciation in his prophetic denunciations of idols: "He shapes it into the figure of a man, with the beauty of a man" (Is 44:13). "They are all the work of *skilled* men," affirms Jeremiah.

Surely nothing stifles art more than the insistence that it be a religion. Such a view, for example, would resist artistic change for its own sake. It might promote change, but only because the prevailing art is "wrong." When it in turn becomes established, it resists anything else and becomes as totalitarian as any of its predecessors. This is the view that issues manifestoes and personal attacks. It is the view that is responsible for all of the sanctimonious criticism and self-pitying artists. Academic heresy hunters, bored

but obedient audiences, backstabbing in the name of a higher and higher culture, are all everywhere in the world of the arts. When people think they are the unacknowledged legislators of humanity, they tend to become elitist and arrogant and thus cut themselves off from authentic artistic sensitivity.

The Bible does not permit us to take art so seriously; it liberates art to be itself. This is certainly true historically. Tribal and pagan art is seldom evaluated aesthetically. The images are so tied into the culture and the religion that they are evaluated according to their function. "It was the Christians," says Werner Jaeger, "who finally taught men to appraise poetry by a purely aesthetic standard—a standard which enabled them to reject most of the moral and re-ligious teaching of the classical poets as false and ungodly, while accepting the formal elements in their work as instructive and aesthetically delightful."[7] Herbert Schneidau credits the Bible with its demythologizing of art and other cultural institutions as being responsible for the unprecedented artistic and cultural change that marks the history of Western civilization.

This freeing of the aesthetic dimension has many implications. Audiences, readers and critics are freed to enjoy art, even if they reject the content that the art is expressing. Or rather, they can ap-prehend the content in a different way. They do not approach a work of art simply for propositional knowledge but for aesthetic understanding. We may read the work of a non-Christian writer in such a way that our apprehension of that writer and that philos-ophy is increased through the aesthetic form without his or her views being seen as absolute truth. We may enjoy art from all ages in a multiplicity of forms. We are also freed from the need to be de-fensive and the need to attack people personally because of their artistic tastes. We are freed from the obligation to be overly respect-ful in the presence of works of art or, better yet, artists.

C. S. Lewis demonstrates this freedom. As a critic, he enjoys art

in an infectious way without taking it with sanctimonious seriousness; he approaches it, for all his interest in Christian orthodoxy, primarily in terms of its aesthetic impact. His book *An Experiment in Criticism* is a model of a truly catholic and far-ranging taste. Lewis here and elsewhere in his critical works is not afraid to challenge the literary establishment. He treats such sacrosanct figures as Eliot and Donne (both Christians) with some irreverence and defends others who have fallen out of favor, such as Shelley (an atheist). He also defends the "less serious" genres such as science fiction, forms beloved by children and the masses but scorned by the high priests of culture. He exults in fictionality:

> A story which introduces the marvellous, the fantastic, says to the reader by implication "I am merely a work of art. You must take me as such—must enjoy me for my suggestions, my beauty, my irony, my construction, and so forth. There is no question of anything like this happening to you in the real world."[8]

One might say that Lewis, the great apologist for "mere Christianity," is arguing here for "mere art"—art accepted for what it is, stripped of pretension, so that it can be received with zest and pleasure.

Mere Art

"Mere art" liberates also the artist. Styles, forms and movements are not sacred; therefore they can be used or changed at will. The gospel always brings liberty. The Christian artist is liberated from the exhausting role of the "doomed genius," from the pressures of Bohemianism and egotistic introspection. If art is not religion, then the artist can go elsewhere and find real religion, faith that can give genuine content and direction to his or her work. When art *is* religion, it tends to be simply about art—which soon becomes horribly, horribly boring. When art and religion are distinct, they can reflect each other. Art can only improve when it is not self-con-

scious, when it looks outside itself to larger contexts and to genuine human concerns. Artists can be better artists if they develop interests and commitments outside the world of the arts.

More importantly, for the artist as a person faith in his or her art alone leads to spiritual death. Isaiah observes that "the craftsmen are but men" (44:11), which means that they have the same limitations, obligations and needs as anyone else. Their God-given talent exempts them from nothing and gives them no special moral or spiritual status. The greatest artists are those who are most fully human. They show in their art that they share and understand the ordinary struggles and demands of life. The picture that Isaiah gives is poignant and tragic, with the craftsman laboriously gathering his materials, planning his design, working and working to the point of exhaustion and then, at his point of need and despair, falling down before what he has made, imploring it to "deliver me, for thou art my god!" (44:17). There can be nothing more futile than such a prayer, yet this scene is played out again and again in the world of the arts. Isaiah continues, giving the answer to his despairing artisan and to everyone in need of deliverance:

Remember these things, O Jacob, and Israel, for you are my servant; I formed you, you are my servant; O Israel, you will not be forgotten by me. I have swept away your transgressions like a cloud, and your sins like mist; return to me, for I have redeemed you. (Is 44:21-22)

The description of an artist forming a god is here countered by the statement that the true God is the one who formed the artist. However great one's skill in creating works of art, God is the ultimate artist. We, for all our talents, are the intransigent raw material that he seeks to form by refining, breaking and molding into "vessels of mercy, which he has prepared beforehand for glory" (Rom 9:23). God, "who hates nothing that He has made" (in the words of the Ash Wednesday Collect), accomplishes this by his action of grace, which offers forgiveness of sins, sweeping them away like mist,

through the redemption accomplished in Jesus Christ.

Art, then, has an important place, but it must not be allowed in any way to replace religion or ethics. C. S. Lewis gives some helpful touchstones for determining priorities: "The Christian knows that the salvation of a single soul is more important than the production or preservation of all the epics and tragedies in the world."[9] That statement bothered me at first, but I was forced to admit that it is true. Lewis says elsewhere, "There are no *ordinary* people. You have never talked to a mere mortal. Nations, cultures, arts, civilizations—these are mortal, and their life is to ours as the life of a gnat. But it is immortals whom we joke with, work with, marry, snub, and exploit—immortal horrors or everlasting splendours."[10]

Art is not only less important than God, it is less important than people. To use artistic taste as a means of snubbing other people, being elitist and condescending, to use art as a means of exploiting or debauching other people, is a common perversion that a Christian must be alert to. A more modest art will be open to human beings; instead of lording it over them, the best art will serve them.

Having said that aestheticism has its limitations and spiritual dangers, it will be helpful now to discuss the truly positive and salutary effects of art. That the Bible explicitly sanctions art and that artistic talent is described by Scripture as a specific gift from God should be clear from the earlier chapters. The aesthetic dimension is valuable in itself, apart from any utility or religious content. In itself it is always safe and God-pleasing. It is when extra-aesthetic matters become attached to art, as they generally will be, that discernment is necessary.

To say that aesthetic pleasure is always good may sound like an overstatement. Surely some pleasure that art gives may be sinful. Some art is pornographic, for example. Some works give pleasure by creating in us sinful fantasies, whether they have to do with sex or anger or power. Some works pander to our prejudices and

reinforce our worst qualities. Certainly artists must keep in mind the solemn, damning words of our Lord that lustful imaginations and angry emotions are as deadly as adulterous and murderous actions (Mt 5:21-30). Christians dare not risk creating sin in anyone. Not only is pornography a moral and spiritual fault, however; it is also an aesthetic fault. The pleasure it gives our sinful nature is not an *aesthetic* pleasure.

Perceptors of Beauty

Here the medieval philosophers are helpful. Beauty is perceived by the *mind*, which contains two faculties: rationality *(ratio)* and intellect *(intellectus)*. *Ratio* is the mind's ability to be logical, mathematical and analytical, to perceive truth by a process and by effort. *Intellectus* is the faculty of immediately perceiving truth, intuitively and directly. According to the medieval philosophers, angels are pure intellect; that is, they perceive God and all things immediately and fully. Fallen humanity, though, at present depends on *ratio*. We can apprehend truth, but we must do so indirectly and piecemeal, through experiments, logical analysis and the accumulation of knowledge through time, although the higher power of the intellect is still operative to a certain extent. To the ancients, beauty is perceived by the intellect. It is common today to say that art appeals to the emotions. Our vocabulary is rather more clumsy than the ancients'. Their view of intellect was wholistic and would include certain parts of what we mean by "emotions." They would insist, however, that beauty is perceived by the mind, not by the more physical "passions."

In fact, our perception of beauty on earth is a glimpse of that total and direct apprehension of the essence of things that the angels and saints in heaven always experience. "For now we see through a glass, darkly; but then face to face: now I know in part; but then shall I know even as also I am known" (1 Cor 13:12 KJV). Now we

cannot even understand earthly things without the cumbersome instruments of scientific, rational analysis. But when we stand before God, we shall know directly, face to face. This fuller perception is not only abstract knowledge, but it is concrete, partaking of the experience of beauty. This point helps us to understand something of the felicity of heaven. The Scriptures speak of the beauty of holiness (1 Chron 16:29; 2 Chron 20:21; Ps 29:2; 96:9 KJV, NIV). "Out of Zion, the perfection of beauty, God shines forth" (Ps 50:2).

> *One thing have I desired of the LORD, that will I seek after; that I may dwell in the house of the LORD all the days of my life, to behold the beauty of the LORD. (Ps 27:4 KJV)*

The Beatific Vision, the direct perception of God enjoyed forever by the saints in heaven, is described by the old theologians as an experience of the ultimate beauty. The beauty of God, the source of all secondary beauties which so enrapture us on earth, permeates heaven, as imaged by the biblical figures of music, song and dazzling light. The blessed, their intellects freed, can now see *everything* in its divinely intended beauty, a beauty which before was obscured by their fallenness and physical limitations.

If, then, beauty is perceived by the intellect, the highest faculty of the mind as shared with angels, it follows that aesthetic pleasure involves a kind of intuitive "knowing" of the highest status, and that it is distinct from other kinds of pleasures. We can see then why pornography is an aesthetic fault. Pornography appeals not to the intellect but to the sexual passions. One may read Updike, say, and respond to his great aesthetic skill. But when he begins describing vivid sexuality, the reader's sexual passions are so engaged that the aesthetic spell is broken. Certainly fallen human beings may experience greater pleasure from the passions than from the intellect. Passions, though, whether they are sexual, violent or sentimental, have nothing to do with beauty, even though

it too is perceived through the senses.

This is why the Greeks banned explicit violence from the stage. Such titillation breaks the aesthetic unity of the work, as is evident in modern cinema. One can become involved in the plot and characters of a film; but when one of the actors takes a chain saw to the others, the aesthetic response of the intuitive intellect is interrupted by physical fear and revulsion. This is also why sentimentality is a fault. Emotionalism may give a certain pleasure, but it is not the pleasure of beauty. It is, literally, a lower pleasure than that of aesthetic satisfaction. This is not to say that such pleasures are not good in their places. Sexual pleasure is a great good in marriage. Art, however, is not the appropriate means for such pleasure. It may be perfectly correct to weep when a puppy is run over, but a poem on the subject is apt to be derided as sentimental if its effect is "tear jerking" rather than aesthetic. So there are aesthetic reasons for avoiding the pornographic, the overly violent and the sentimental. But the experience of beauty, in all its complex forms, is always good and even exalting.

The point is this: beauty in itself is valuable because it is a quality of the Godhead. Moreover, he expressed this quality in his creation. Human beings can both perceive and create beauty because they are made in the image of God.[11] Thus Augustine says that "those beautiful patterns, which through the medium of men's souls are conveyed into their artistic hands, emanate from that Beauty which is above our souls, which my soul sigheth after day and night."[12] Augustine in the context warns about being ensnared by mere worldly beauties, but he points to their true source as God, who works through the artistic hands of human beings.

George MacDonald observes how aesthetic experience can elevate the mind:

Whatever it be that keeps the finer faculties of the mind awake, wonder alive, and the interest above mere eating and drinking,

money-making and money-saving; whatever it be that gives gladness, or sorrow, or hope,—this, be it violin, pencil, pen... is simply a divine gift of holy influence for the salvation of that being to whom it comes, for the lifting of him out of the mire and up on the rock. For it keeps a way open for the entrance of deeper, holier, grander influences, emanating from the same riches of the Godhead. And though many have genius that have no grace, they will only be so much the worse, so much nearer to the brute, if you take from them [their art].[13]

In other words, the arts shield us from mere materialism. They cannot save of themselves, but they are still exalting. They make us more human, more what God created us to be, and less animallike. They involve a perception of qualities, of values, that transcend the narrow, empty world of materialism and brutishness.

The Role of Imagination

The imagination in particular—that amazing gift by which we can perceive nonmaterial images in our mind—is a vital power that is healthy for us to use. We can conjure up past experiences and bring them to present consciousness. We can formulate experiences in our minds that we have never had before. We can create new configurations that have never existed. We can do all these things at will through the power of the imagination.

Samuel Johnson, at the conclusion of *Rasselas,* uses this faculty as a proof of the immortality of the soul and the existence of a spiritual realm. Rasselas says that he cannot conceive of anything without extension in space and therefore the possibility of destruction.

"Consider your own conceptions," replied Imlac, "and the difficulty will be less. You will find substance without extension. An ideal form is no less real than material bulk: yet an ideal form has no extension. It is no less certain, when you think on a pyramid, that your mind possesses the idea of a pyramid, than that

the pyramid itself is standing. What space does the idea of a pyramid occupy more than the idea of a grain of corn? or how can either idea suffer laceration? As is the effect such is the cause; as thought is, such is the power that thinks; a power impassive and indiscerptible."[14]

Modern neurology notwithstanding, the faculty of imagination enables us to conceive of things beyond our limited sensory means of perception. It opens our minds to other kinds of reality. In his autobiography C. S. Lewis says that when he read George Mac-Donald, his imagination was "baptized."[15]

It is difficult to believe in the existence of God if one is unable to "imagine," however faintly, a being of infinite goodness and power. It is difficult to aspire to a moral life if one cannot imagine its attractiveness. It is difficult to appreciate the work of Christ if one cannot imagine the magnitude of the incarnate God being nailed to a cross and bearing in himself the sins of the world. One must be cautious here—I am not saying that a subjective imaging of such things is necessary to faith; indeed, one must be careful of basing belief on what one imagines rather than on the objective revelation of God (Rom 1:21). I am saying that the imagination, saturated in Scripture, can be helpful in the Christian's realizing the extent and magnitude of the Christian message.

Imagination is especially helpful in the ethical life. When the apostle Paul exhorts us to "rejoice with those who rejoice, weep with those who weep" (Rom 12:15), he is asking for an exercise of the imagination. We are to assume the point of view of someone else and imaginatively experience what he or she is experiencing. This sort of empathy is a habit of mind that the arts encourage. In reading a novel, we assume the point of view of its characters. In studying a painting, we enter into the vision of the artist, seeing things as the artist sees them. To be able to rejoice with those who rejoice, to understand the manifold reasons for joy in existence, and

to weep with those who weep, to empathize with those who suffer physically or who are lost in the dizzying abyss of despair, is commanded by Scripture, opening up the whole range of human experience to artists.

If the perception and creation of beauty, the powers of the imagination, the capacity for empathy, are all gifts of God, it follows that the proper use of the arts is a matter of stewardship. Any of God's gifts can be used or abused. They can be made to multiply or they can be buried in the ground. God's gifts to Bezalel—inspiration, ability, intelligence, knowledge, craftsmanship, teaching, all of which together constitute the arts—come under God's command that we be good stewards.

The arts must not be buried. In the parable of the unfaithful steward, the steward was afraid to use the gifts his master had entrusted to him, and he was condemned for being too scrupulous and legalistic (Mt 25:14-30). Gifts are to be used, to be multiplied. God will hold us to account for how we have used his gifts.

The Good Gift

We dare not despise art. If God gives us artistic talent, we are obligated to develop that talent. If God gives us an aesthetic experience—a glimpse of a beautiful landscape, the satisfaction of a good novel, the pleasing forms of a painting or sculpture—we must not cover our eyes, spurning God's gift of beauty. Rather we are obligated to linger over it, to enjoy it fully and to glorify God. The Christian artist in particular is called to be a steward:

As each has received a gift, employ it for one another, as good stewards of God's varied grace: whoever speaks, as one who utters oracles of God; whoever renders service, as one who renders it by the strength which God supplies; in order that in everything God may be glorified through Jesus Christ. (1 Pet 4:10-11)

The arts are part of the "varied grace" of God. A person who, like

Bezalel, receives the gifts for art is to use them for the sake of others, rendering them service which is to be understood as coming not from the self but from God.

The Christian artist must realize that a biblical view of the arts is profoundly liberating. Because art is not sacred, it can be changed. Because of the Second Commandment, it can be nonrepresentational, fictional and creative. Because the aesthetic is valuable *in itself*, as a God-ordained realm of experience, the Christian artist need not always be expressing explicit religious messages. The artist is freed to pursue aesthetic excellence. Any type of art, from architecture to electronic music, from crafts such as needlework to the most ethereal art of the museums, can be pleasing to God and a legitimate use of his gifts.

The artist has no innate moral or spiritual superiority to anyone else and is subject to the temptations of the world, the flesh and the devil, just as everyone is, although these manifest themselves in sometimes unusual ways in the art world. Nevertheless, God's Word can deliver artists from these distorting, desensitizing powers, and the community of the Church can give them the spiritual balance and the personal support they must have. Christian artists must realize that God is with them in their struggles and looms behind their compulsion and ability to fill the blank canvas, to write on the empty page, to create something where there was nothing.

Bezalel was called by name. God empowered him with the gifts necessary to make designs "for glory and beauty." These gifts—the Spirit of God, ability, intelligence, knowledge, craftsmanship and the inspiration to teach—are rare and precious and are to be honored wherever they appear. Scripture honors them in five successive chapters, not only in the calling and equipping of Bezalel, but in the detailed account of the variety and magnificence of his works. Nearly every verse in Exodus 36—39 repeats the litany, referring

back to Bezalel, that "he made . . . and he made," a phrase repeated
fifty-five times in the four chapters:

> *And he made loops of blue. . . . And he made fifty clasps of gold. . . .*
> *He made eleven curtains. . . . Then he made the upright frames for*
> *the tabernacle of acacia wood. . . . And he made the veil of blue and*
> *purple and scarlet stuff and fine twined linen; with cherubim skil-*
> *fully worked he made it. . . . Bezalel made the ark of acacia wood. . . .*
> *And he made a mercy seat of pure gold. . . . And he made two cheru-*
> *bim of hammered gold. . . . He made the holy anointing oil also. . . .*
> *And he made the laver of bronze and its base of bronze, from the mir-*
> *rors of the ministering women. . . . The onyx stones were prepared,*
> *enclosed in settings of gold filigree. . . . Bezalel the son of Uri, son of*
> *Hur, of the tribe of Judah, made all that the LORD commanded Moses.*
> *(Ex 36–39)*

Such passages may seem tiring to some—descriptions of artifacts
that have been lost for thousands of years, details of a mode of wor-
ship long superseded, blueprints of incomprehensible designs. Yet
it pleased God to include these passages in Holy Scripture, all of
which he declares to be "profitable for teaching, for reproof, for
correction, and for training in righteousness" (2 Tim 3:16).

What we are to learn from these passages is that God loves crafts-
manship and design, that he exults not only in his own creation
but also in the creations of human beings—in the works of Bezalel
and of all artists who follow him.

Notes

Preface
 [1] The distinction between law and gospel, the emphasis on Christian freedom, the affirmation of both the sacred and the secular realms, and the general method of handling and interpreting Scripture all derive from Lutheran theology. Although not all Christians would agree with every detail of this theology or would employ the same hermeneutic, they would nevertheless, I believe, come to similar or compatible conclusions about what the Bible says about art even though through different routes. Still, the Lutheran tradition, which has always been especially open to the arts, is uniquely helpful in showing how Bible-believing, evangelical Christians can relate to art.

Chapter 2: The Gifts of Bezalel: The Bible and the Vocation of the Artist
 [1] Quotations from Calvin are from *Institutes of the Christian Religion*, trans. Ford Lewis Battles, ed. John T. McNeill, The Library of Christian Classics (Philadelphia: Westminster Press, 1960). References are to Calvin's divisions by book, chapter and section.

Chapter 3: The Idolatry of Aaron: The Misuse of Art
 [1] Flannery O'Connor, *The Violent Bear It Away* (New York: Farrar, Straus & Giroux, 1955), p. 8.

[2]See, for an example of a Kierkegaardian perspective on the question, W. H. Auden's essay "Postscript: Christianity and Art" in *The Dyer's Hand*, reprinted in the anthology *Religion and Modern Literature: Essays in Theory and Criticism*, ed. G. B. Tennyson and Edward C. Ericson, Jr. (Grand Rapids, Mich.: Eerdmans, 1975), pp. 114-18.

Chapter 4: The Works of Bezalel: Art in the Bible

[1]Francis A. Schaeffer, *Art and the Bible* (Downers Grove, Ill.: InterVarsity Press, 1974), p. 12.

[2]Ibid., p. 16.

[3]See H. R. Rookmaaker, *Modern Art and the Death of a Culture* (Downers Grove, Ill.: InterVarsity Press, 1970).

[4]*Antiquities of the Jews*, bk. 18, chap. 3, sect. 1; from *Josephus: Complete Works*, trans. William Whiston (Grand Rapids, Mich : Kregel Publications, 1960), p. 379.

[5]Annie Dillard, *Pilgrim at Tinker Creek* (New York: Bantam, 1975), pp. 132, 114, 129-30; her emphasis.

[6]See my article "Defamiliarizing the Gospel: Shklovsky and a Theory of Religious Art" in *Christianity and Literature* 28 (1979), 40-47.

[7]Schaeffer, *Art and the Bible*, p. 14.

[8]For the differences between the Hebrews and their neighbors, see Herbert N. Schneidau, *Sacred Discontent: The Bible and Western Tradition* (Berkeley: Univ. of Calif. Press, 1977).

[9]See Schneidau, ibid., who argues that our Western culture is open to change precisely because our biblical heritage prevents us from making any cultural form absolute, in marked contrast to civilizations based on "myth."

[10]See Psalms 33:3; 40:3; 96:1; 98:1; 144:9; 149:1. See also Luke 5:36-39.

Chapter 5: The Heirs of Bezalel: The Tradition of Biblical Art

[1]This discussion is indebted to Thorleif Boman, *Hebrew Thought Compared to Greek*, trans. Jules C. Moreau (Philadelphia: Westminster Press, 1960).

[2]See ibid., pp. 77-81.

[3]See Schneidau, *Sacred Discontent*.

[4]See Eric Auerbach, *Mimesis: The Representation of Reality in Western Literature* (Princeton: Princeton Univ. Press, 1953), not only for the impact of the Hebraic imagination on fiction, but also for a close analysis of the difference between biblical and classical narration (pp. 3-23).

[5]See Henry James's short story, "The Figure in the Carpet."

[6]See Augustine *Confessions* 7. 9.

[7]See J. R. R. Tolkien, "On Fairy Stories," *The Tolkien Reader* (New York: Ballantine Books, 1966), pp. 46ff.

[8]Calvin *Institutes* 11. 12.

[9]Quoted in Charles Garside, *Zwingli and the Arts* (New Haven: Yale Univ. Press, 1966), p. 171.

[10]Quoted ibid., p. 182.

[11]Lawrence Sasek, *The Literary Temper of the English Puritans* (Baton Rouge: Louisiana State Univ. Press, 1961), p. 116.

Chapter 6: The Brazen Serpent: Art and Evangelism
[1]The relation of law to gospel is set forth in Romans and Galatians. The particular emphasis followed here derives from Martin Luther. For a classic discussion, see C. F. W. Walther, *The Proper Distinction between Law and Gospel* (St. Louis: Concordia, 1928).

[2]Just as they are under God's law as administrators of his wrath, they will themselves be judged by that law. That God works through them does not justify their tyranny but rather condemns them more. That there is a law above the social law means that when there is a conflict, "we must obey God rather than men" (Acts 5:29).

[3]It is often said that moral values vary from culture to culture. For evidence that this is really not the case, see C. S. Lewis, *The Abolition of Man* (New York: Macmillan, 1947).

[4]Stanley Fish, *Self-Consuming Artifacts: The Experience of Seventeenth-Century Literature* (Berkeley: Univ. of Calif. Press, 1973), pp. 1-21, 378.

[5]See Nelvin Vos, "The Religious Meaning of Comedy," in *The Christian Imagination: Essays on Literature and the Arts*, ed. Leland Ryken (Grand Rapids, Mich.: Baker, 1981), pp. 241-53.

[6]Schneidau, *Sacred Discontent*.

[7]Quoted from *English Seventeenth-Century Verse*, ed. Louis L. Martz (New York: W. W. Norton, 1973), 1:144.

[8]T. S. Eliot, *The Complete Poems and Plays, 1909-1950* (New York: Harcourt, Brace & World, 1958), p. 21.

[9]"The Displaced Person," in *Three by Flannery O'Connor* (New York: New American Library, 1955), pp. 290-91.

[10]See Francis Schaeffer's discussion of this painting in *How Should We Then Live? The Rise and Decline of Western Thought and Culture* (Old Tappan, N.J.: Fleming H. Revell, 1976), p. 66.

[11]Garside, *Zwingli and the Arts*, pp. 172-73.

[12]Charles Williams, *The Figure of Beatrice: A Study in Dante* (London: Faber & Faber, 1943).

Chapter 7: Mere Art
[1]A distinction discussed by C. S. Lewis in *An Experiment in Criticism* (Cambridge: Cambridge Univ. Press, 1961).

[2]C. S. Lewis, *The Great Divorce* (New York: Macmillan, 1946), p. 81.

[3]"A Defence of Poetry," in *The Norton Anthology of English Literature*, ed. M. H. Abrams et al., 4th ed. (New York: W. W. Norton, 1979), 2:784.

[4]"The Study of Poetry," in *Poetry and Criticism of Matthew Arnold*, ed. A. Dwight Culler (Boston: Houghton Mifflin, 1961), p. 306.

[5]Ibid., p. 314.

[6]Ibid., p. 318.

[7]Werner Jaeger, *Paideia: The Ideals of Greek Culture*, trans. Gilbert Highet (1935; rpt. New York: Oxford Univ. Press, 1965), pp. xxvii-xxviii.

[8]Lewis, *Experiment in Criticism*, p. 50.

[9]"Christianity and Literature," in *Religion and Modern Literature*, p. 53.

[10]"The Weight of Glory," in *They Asked for a Paper* (London: Geoffrey Bles, 1962), p. 210; his emphasis.

[11]See Dorothy L. Sayers, *The Mind of the Maker* (San Francisco: Harper & Row, 1941).

[12]Augustine *Confessions* 34, in *Basic Writings of St. Augustine*, ed. Whitney J. Oates (New York: Random House, 1948), 1:174.

[13]George MacDonald, *Robert Falconer* (New York, 1870), p. 88.

[14]Samuel Johnson, *Rasselas*, chap. 48, in *Johnson: Prose and Poetry*, ed. Mona Wilson (Cambridge: Harvard Univ. Press, 1967), p. 481.

[15]C. S. Lewis, *Surprised by Joy* (New York: Harcourt, Brace & World, 1955), p. 181.